ARCHITECTURE OF
resignation

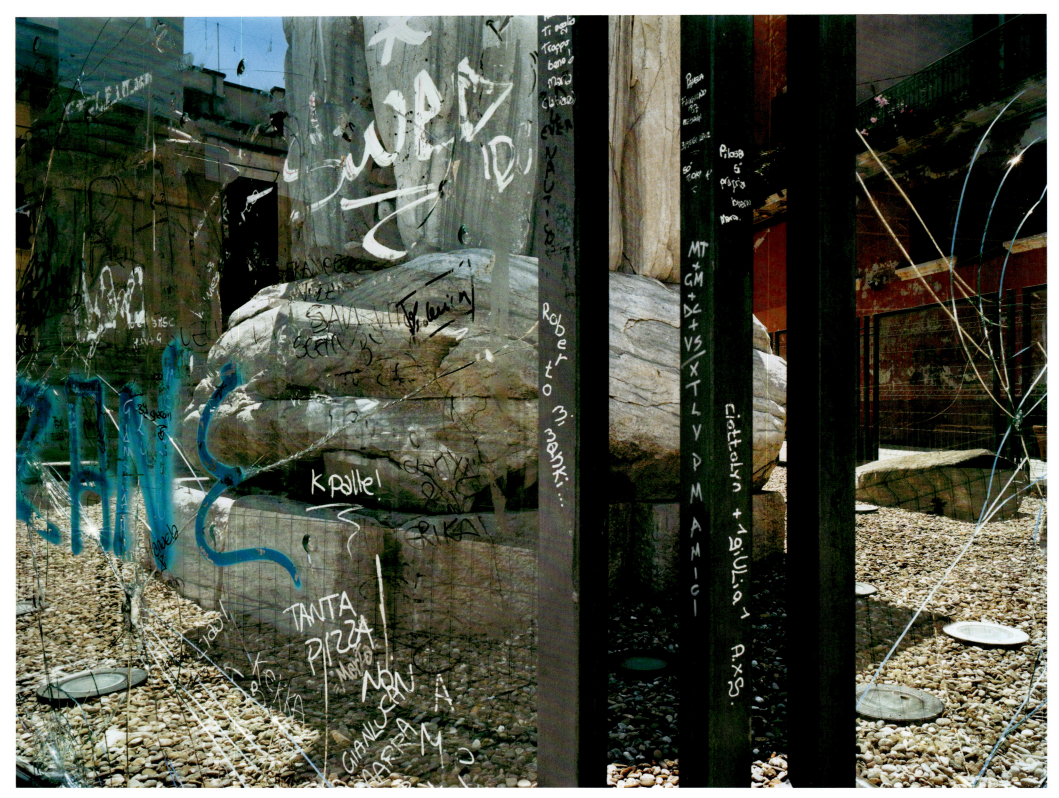

VIA APPIA END. BRINDISI, PUGLIA, 2007.

ARCHITECTURE OF
resignation

Photographs from the Mezzogiorno

JAY WOLKE

with essays by Roberta Valtorta and Tom Bamberger

CENTER FOR AMERICAN PLACES AT COLUMBIA COLLEGE CHICAGO

Copyright © 2011 Jay Wolke and the Center for American Places at Columbia
College Chicago

All rights reserved. No text or photograph may be used or reproduced in any
form or medium without written permission.
Published in 2011. First Edition.
Printed in Singapore on acid-free paper.

The Center for American Places at Columbia College Chicago
600 South Michigan Avenue
Chicago, Illinois 60605-1996, U.S.A.
www.colum.edu/centerbooks

Distributed by the University of Chicago Press
www.press.chicago.edu

20 19 18 17 16 15 14 13 12 1 2 3 4 5

Library of Congress Cataloging-in-Publication Data

Wolke, Jay.
 Architecture of resignation : photographs from the Mezzogiorno / Jay Wolke ;
with essays by Roberta Valtorta and Tom Bamberger.
 p. cm.
 ISBN 978-1-935195-13-9 (hardback)
 1. Italy, Southern—Pictorial works. I. Valtorta, Roberta. II. Bamberger, Tom.
III. Title.
 DG820.5.W65 2011
 945'.7—dc23
 2011019123

CONTENTS

vii

A Journey to Italy
in the Third Millennium
by Roberta Valtorta

3

The Plates

65

Working in the Field
by Tom Bamberger

71

The Architecture of Resignation
by Jay Wolke

73

Notes on the Plates

77

Acknowledgments

79

About the Photographer
and the Essayists

v

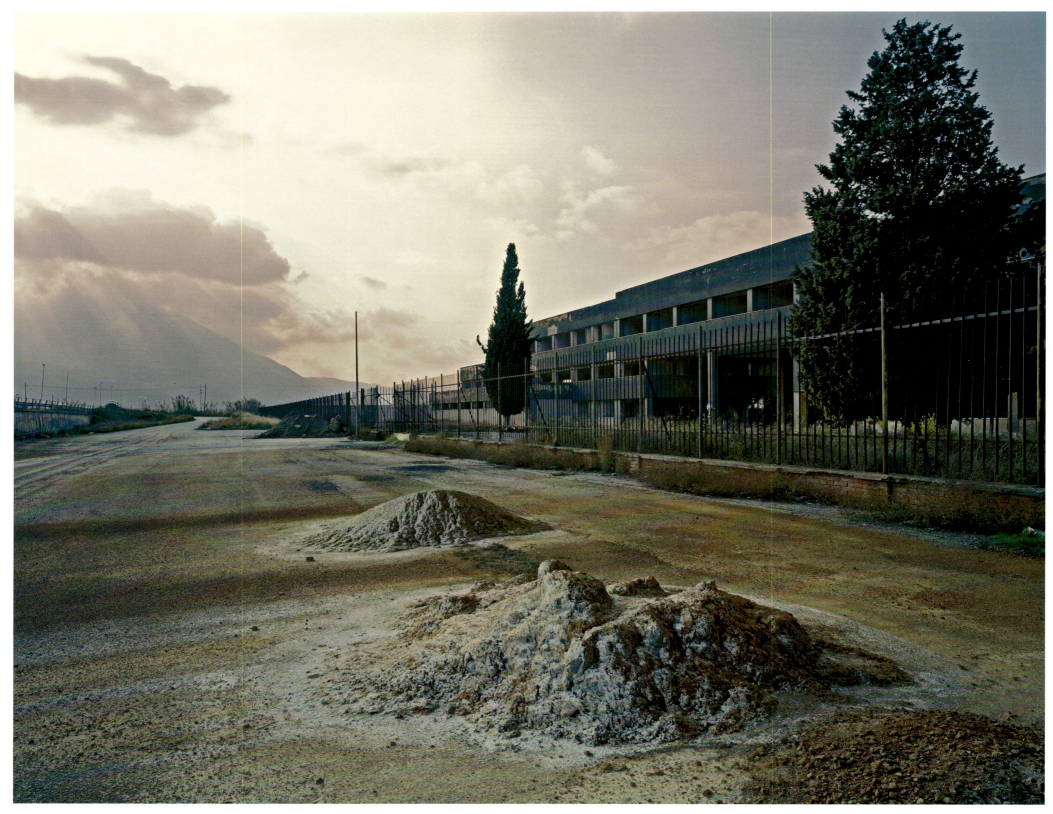

BLUE PILES; ABANDONED FACTORY. TERMINI IMERESE, SICILY.

A Journey to Italy
in the Third Millennium

by Roberta Valtorta

Italy is a country where nature, history, and art are deeply interlaced. When you look into a forest you not only see trees, shade, and bushes or imagine what kind of animals may live within it, you also envision what ancient town, from a very distant past, might be hidden within. You see nature but think of culture. If you look at a solitary meadow, you may imagine what historic battle was fought there and when it happened. Again, you see nature but think of history. When you enter a piazza, framed by ancient palazzi and churches, you are reminded of the many artists who had been engaged in building and decorating them. Paintings, sculptures, architecture, and ruins are everywhere in Italy—in the towns, in the country, on the coasts, and in nearly every village. Art is everywhere. The *bel paese*, as Dante named it, is a complex whole of so many elements belonging to nature and to culture that you cannot stop wondering how it was possible, throughout the centuries, to create a country so rich in stratifications. Italy is a *museo diffuso*, a collection

of widely varying forms and types, in which the landscape is a museum piece. Italian cultural heritage—"the continuum of monuments, towns, citizens"—is the landscape; everything forms a "connective texture."[1]

Travelers, tourists, noblemen and bourgeoisie, writers, artists (painters and sculptors at first, photographers later on) were fascinated and infatuated with the country, the culture, and the landscape when they visited Venice, Genoa, Florence, and Rome during the "grand tour," a popular adventure from eighteenth century onwards. The ancient sites of Southern Italy and Sicily were the final, symbolic destinations on the tour of the mythic origins of Mediterranean civilization, to the roots of the world—a journey to Paradise.

These are the same places that are today the "architecture of resignation," of Jay Wolke's work. He makes a contemporary grand tour, a completely new journey to southern Italy, which is today a place of desolation. Jay Wolke's photographs bring to mind an exhibition catalog from a show recently held in Paris, *Voir l'Italie et mourir (See Italy and Die)*, which documents the representation of the Italian landscape, art, and people in nineteenth century painting and photography.[2] In Wolke's hands "see Italy and die" seems to change completely. To day, sorrow takes the place of wonder. It was once believed that, after seeing Italy, you could feel satisfied with your life and die at peace. In these pictures it seems that if you see Italy you might feel like dying. But there is still mystery: how is it possible to spoil such a noble place, to destroy a historic culture and special landscape? What has happened, and when?

During the long course of history the Greeks, Romans, Normans, French, Spanish, as well as Arabs and Albanians (and, in the end, Italians, when in 1861 the Savoia unified the country) left so many important marks in the territories of Southern Italy. In time, a multicultural society has persevered like a surprisingly coherent ecosystem of aristocracy and farmhands, nobles and slaves. And yet this landscape of paradise is riddled with injustice, backwardness, and thievery. Because industrialization was slow to reach southern Italy and its people during the nineteenth century, the landscape of paradise could endure. After World War II, as the feudal society continued to fracture, a significant portion of the population began to leave the region for new economic opportunities. Very slowly a different kind of economy began to grow in the south and, as some industrial activity developed, those who remained were transformed from farmhands into factory workers, perpetuating a long-standing class struggle. The "southern problem" has never been successfully addressed by the Italian government, and today warrants its own cultural epithet, il mezzogiorno. Instead, local solutions—*Mafia, camorra, 'ndrangheta*—have been the real modernizing force in the *mezzogiorno*. Organized crime is a parallel government, a parallel power. Not always so parallel though, because in too many cases the coincidence between mafia and economic and political power is completely complimentary and, unfortunately, no longer confined to the South.

An ephemeral and chaotic landscape has emerged (and again, not only in the south, but all over the country) as a mirror of this historical-political

drama. Wolke photographs precisely the disappointing, incredible calling card of the *mezzogiorno* today. The most obvious visual symbols of this complex reality are certainly the half-built buildings. Italy is an unfinished country, an unfinished culture, an unfinished democracy; it is a history that has paused and cannot progress, an interrupted communication. Through-ways, shipyards, horrible contemporary architecture, and public housing projects exist too close to ancient churches and palaces. New, absurd artifacts and architecture are lost in a dazzling sunbathed landscape that remains ancient and enchanting. "Resignation"—we are resigned that there is no escape. Nature and culture are at war. Bad taste, aesthetic disaster, lack of respect for laws and rules and backwardness are the same thing, and it has become a visual question.

Photography illustrates this conflict very clearly because photography is a fragment of reality. It is an index of a larger scene, and each fragment within the scene has tremendous meaning. The more we study landscape photography, the more we understand that when you photograph a natural landscape from up-close you may discover unbelievable worlds of beauty, but if you take photographs of an altered landscape from up-close you may easily identify terrible problems. Contemporary landscape, whether in Italy or elsewhere, is composed of fragments. It is a perfect subject for photography. When landscape was harmoniously coherent, painting depicted it well. Industrialization coincided with the inability of painting to capture the nature of landscape. A new art emerged better able to depict the new environment. Photography, in fact, is an art created by industry itself. Photographers, keenly aware that the world was losing its beauty, gravitated toward the industrial landscape. They understood that the work of the photographer was no longer to capture "beauty," but to try to narrate what the world had become: a landscape continuously shaped and altered, with no conscious regard for beauty or ugliness. The process of fragmentation within the contemporary landscape has strengthened and accelerated in the post-industrial period. In such a "beautiful country" as Italy, this phenomenon of growing fragmentation becomes more evident and jarring, and even more so in the mezzogiorno, where the natural landscape was, in effect, too beautiful.

The large-format detail and color saturations used by Wolke create powerful fragments that show evidence of the clash between the beauty of landscape, its shapes and colors, and the detritus of human artifacts in the clash between the architecture of the past and of the present. Harmony, not only from an aesthetic but also from an anthropological point of view, seems to be lost. These places belong to the category of "no-places," using a phrase that the French anthropologist Marc Augé chooses to indicate places that are no longer identifiable, relational, historic, but are created in relation to money, power, and politics.[3] Wolke's photographs are melancholy, yet seriously documentary. Color and content evoke sadness. The beautiful sky of Southern Italy looks threatening. The quality of fragment is very important in this kind of photography. The more isolated

the monuments, the stronger they are on a symbolic level. There may be a marvelous landscape beyond the frame but we cannot see it within the rectangle of the photograph—it must not exist.

There is a moment for every society: the Italian moment seems to have come to an end. Wolke chose the mezzogiorno for his photographic work at exactly the time when degradation of the environment and urban decay have reached an extreme level. In the regions where Wolke worked (Sicily, Puglia, Calabria, Basilicata, Campania, and Lazio), he selected specific situations and artifacts such as unfinished tunnels, gates to nowhere, churches that look bizarre and out-of-place in the surrounding environment, enormous blocks of public housing such as the Vele di Scampia in Naples (I ask myself, how many times have we discussed their blasting?), skeletons of houses, and abnormally attenuated bridges such as Il ponte Bisantis in Catanzaro. His subjects are wounds in the landscape—"monuments" of a culture of resignation, a culture of mistakes, connivance, neglect, and desperation.

One thing must be stressed, however. Catholic culture, strongly and deeply rooted in Italian culture, makes the attitude of resignation somewhat understandable. It is inconsequential if, in worldly life, one makes mistakes or breaks laws and rules, for there is still another life to be lived. So in the end the earthly world in which you live is not the most important. Moreover, there is no need to worry about consequences—confession will always redeem you. Even the most high-ranking men of the mafia believe in this tenet of Catholicism. And, to make things even more complicated, the Catholicism of the mezzogiorno is based on more ancient, pre-Catholic pagan religions and rituals emphasizing a strong belief in fate that permeates every action and every behavior.

Wolke is not interested in looking for classic or traditional beauty in the landscape. He is interested in seeing social and political processes in the altered landscape. He has made a contemporary grand tour of Italy and, like an anthropologist, has tried to analyze the arrogance and power in the contradictions, the chaos and disaster he has found. The history and fate of the Italian landscape belongs to a more general mystery: why do men spoil and destroy the land on which they live? It is as the French philosopher Michel Serres explained, there is a strong link between spoiling and ruling or dominating something.[4] The mezzogiorno has always been ruled, though never governed. The people, ancient and contemporary, living there, have always resigned themselves to being dominated. Wolke's confrontational documentary style expresses the southern Italian reality quite well leaving no need to enhance the drama through deliberate and subjective photographic interpretations. Very respectfully and thoughtfully, he has made a new set of postcards of the bel paese, sending them from along the journey to the mezzogiorno in the third millennium.

NOTES

1 Salvatore Settis, *Italia S.p.A. L'assalto al patrimonio culturale* (Turin, Einaudi, 2002).

2 Ulrich Pohlmann, Guy Cogeval, et al, *Voir l'Italie et mourir* (Paris: Musée d'Orsay/Skira Flammarion, 2009).

3 Marc Augé, *Nonlieux* (Paris: Seuil, 1992).

4 Michel Serres, *Le mal propre* (Paris: Le Pommier, 2008).

ARCHITECTURE OF
resignation

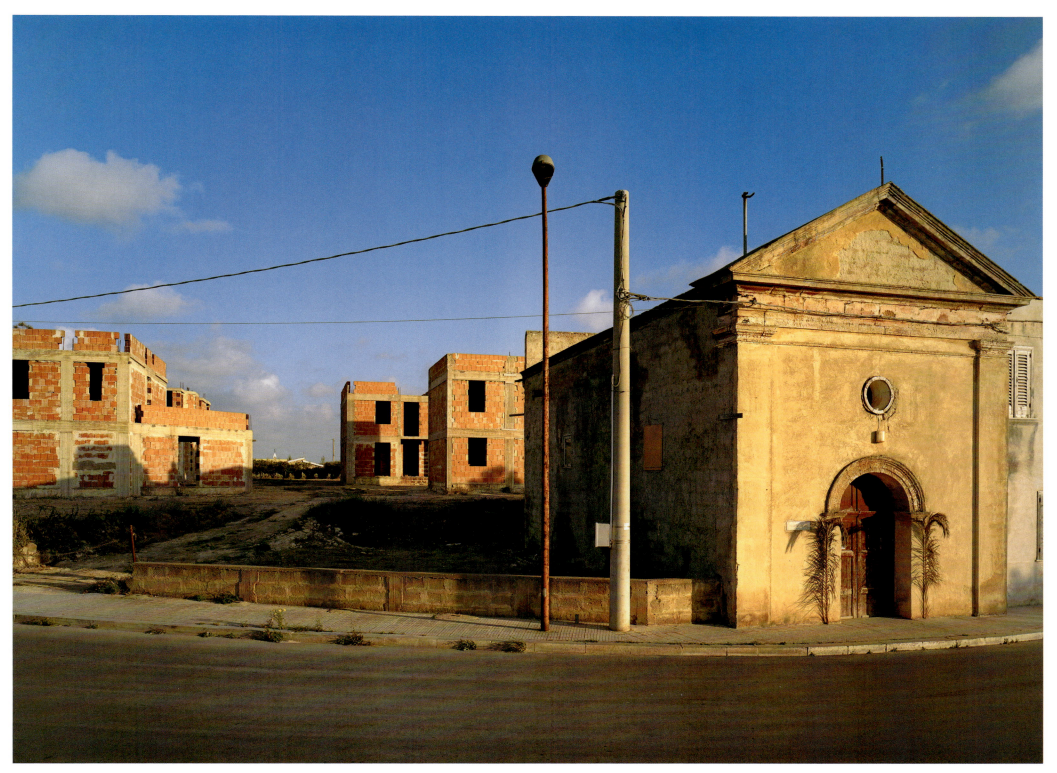

CHURCH; PALMS. MARSALA, SICILY, 2000.

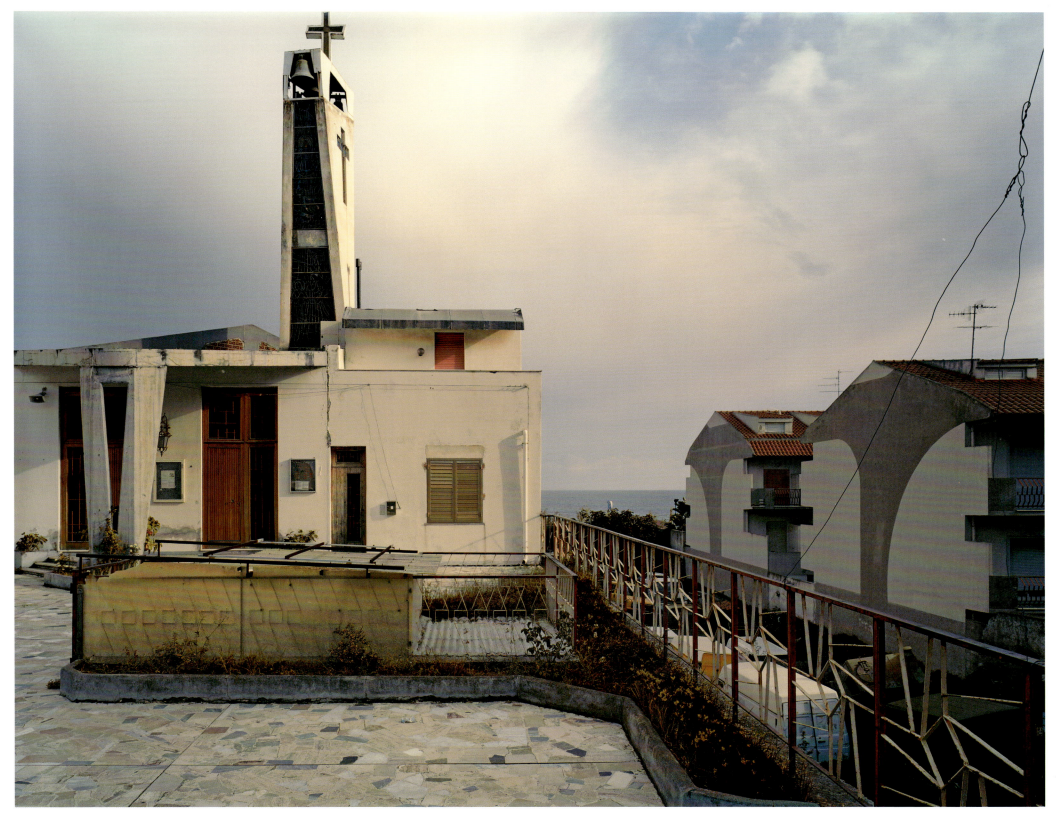

CHURCH; VANS. NIZZA DI SICILIA, 2005.

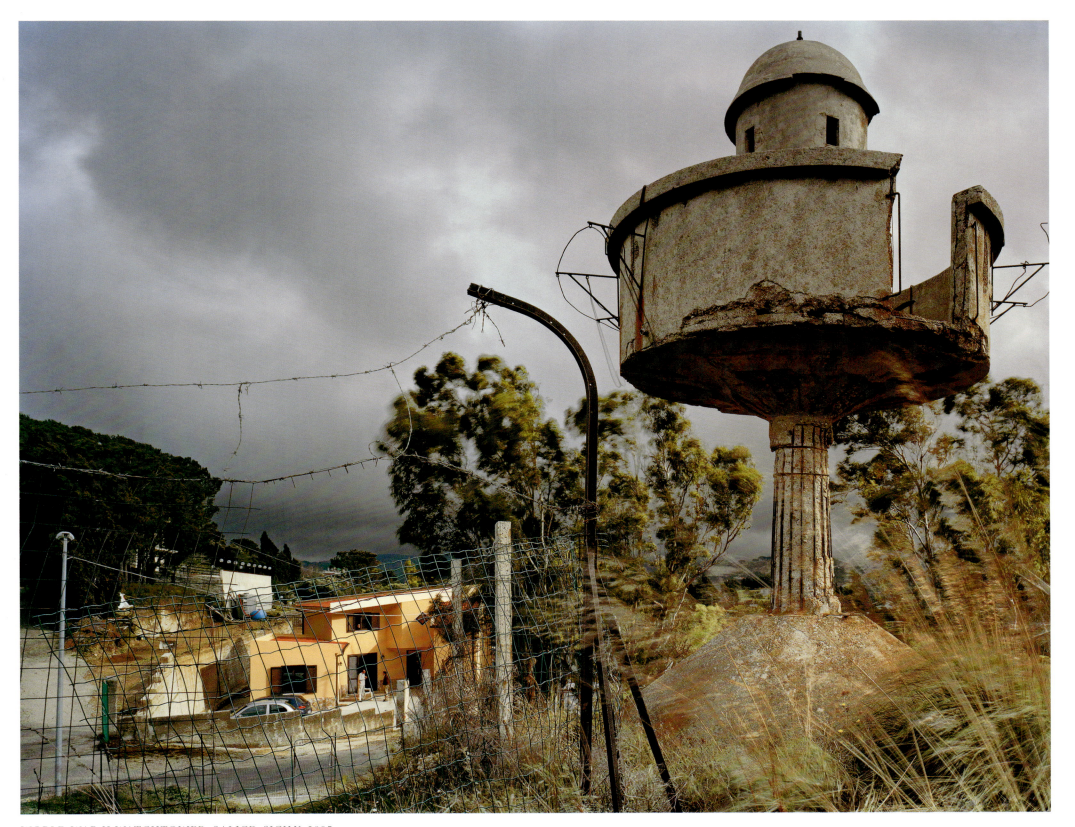

WORLD WAR II WATCHTOWER. SALICE, SICILY, 2005.

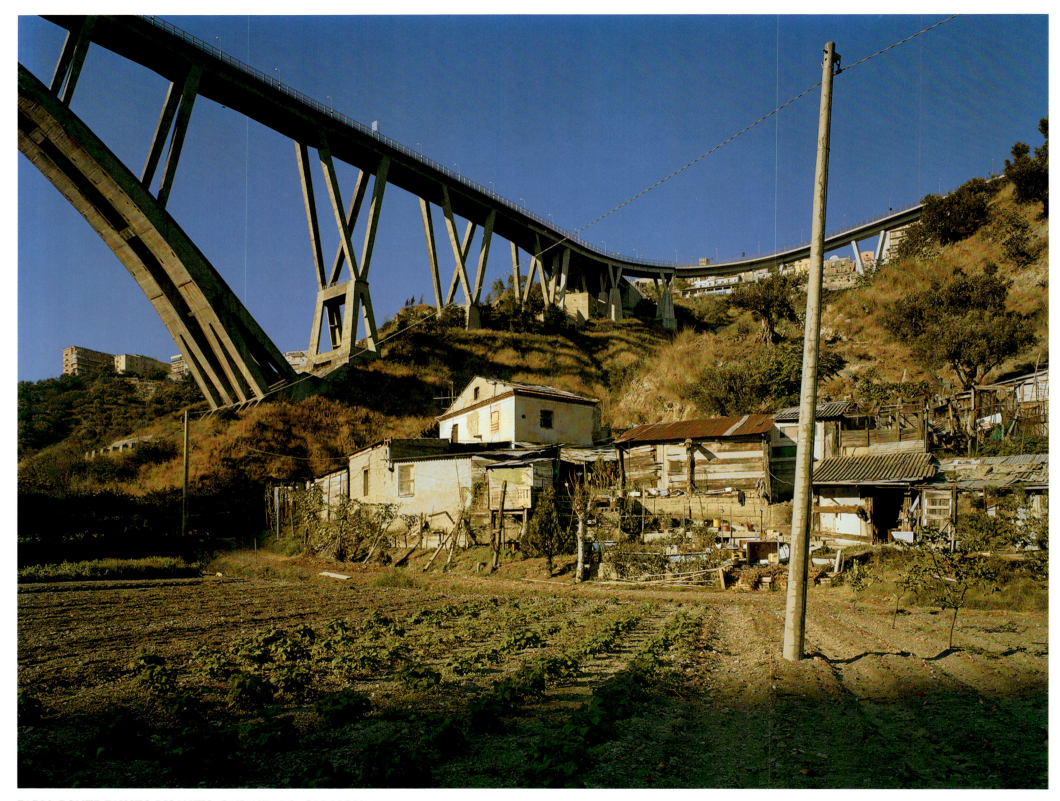

FARM; PONTE FAUSTO BISANTIS. CATANZARO, CALABRIA, 2001.

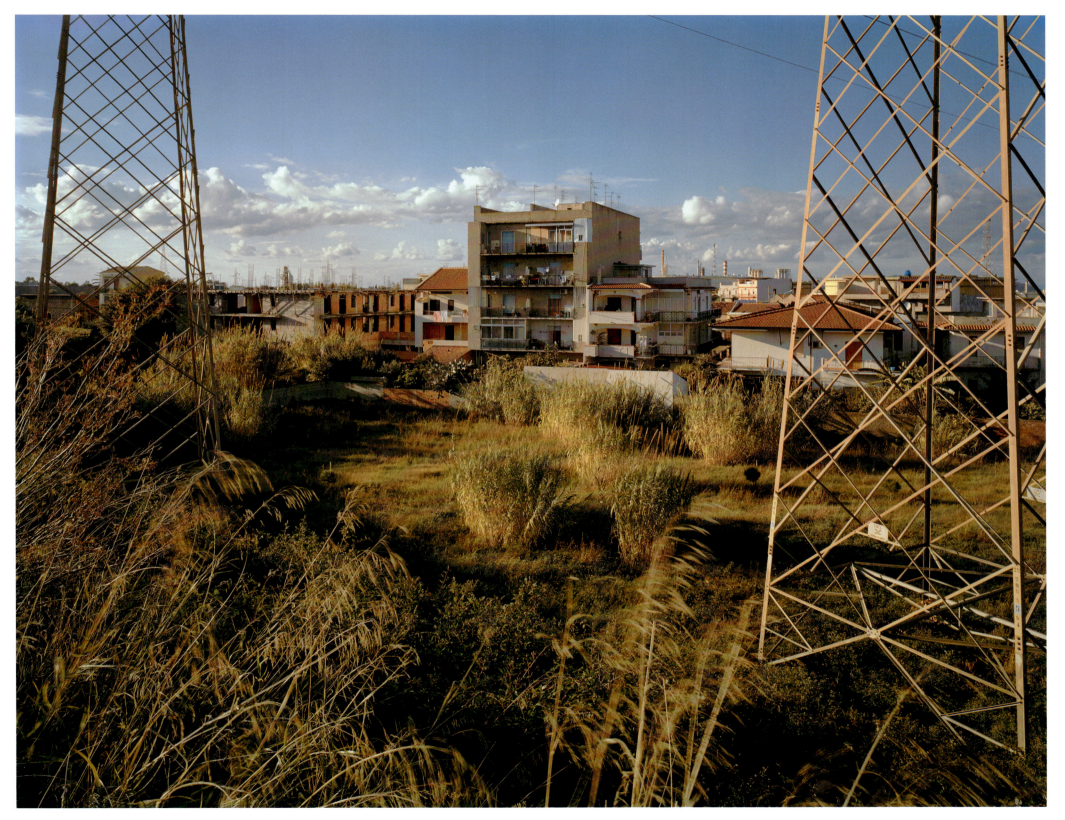

TRANSMISSION TOWERS. MILAZZO, SICILY 2005.

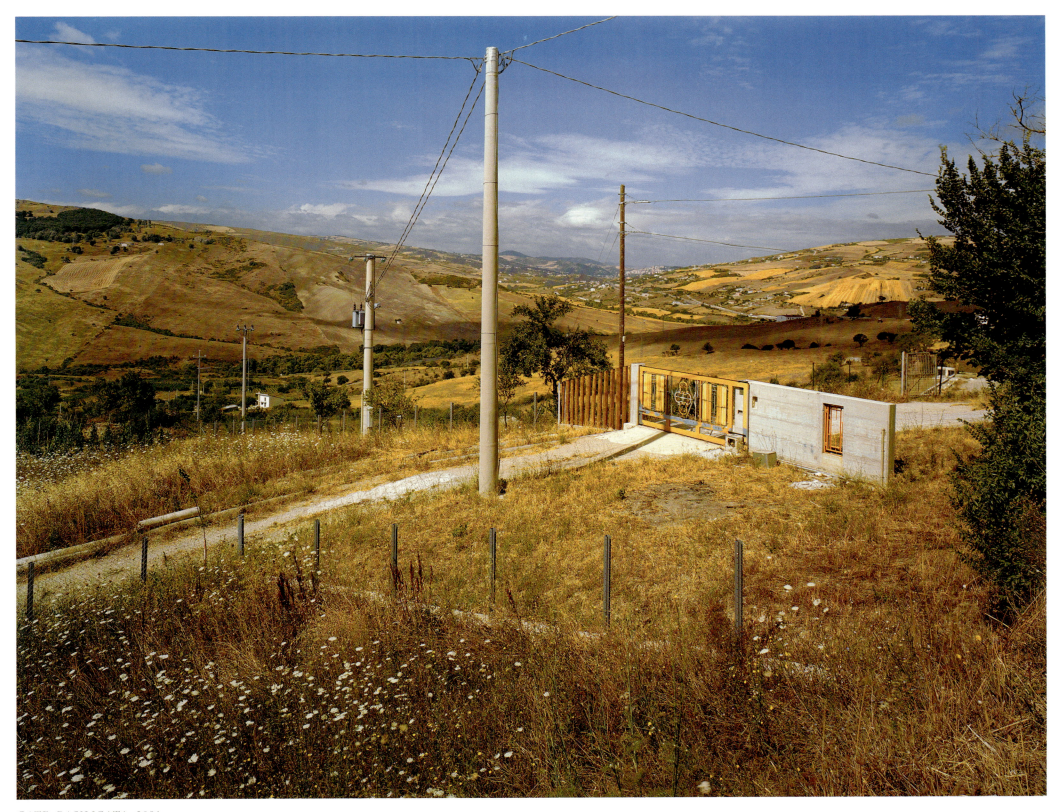

GATE. BASILICATA, 2001.

SANCTUARIO. VENETICO, SICILY, 2005

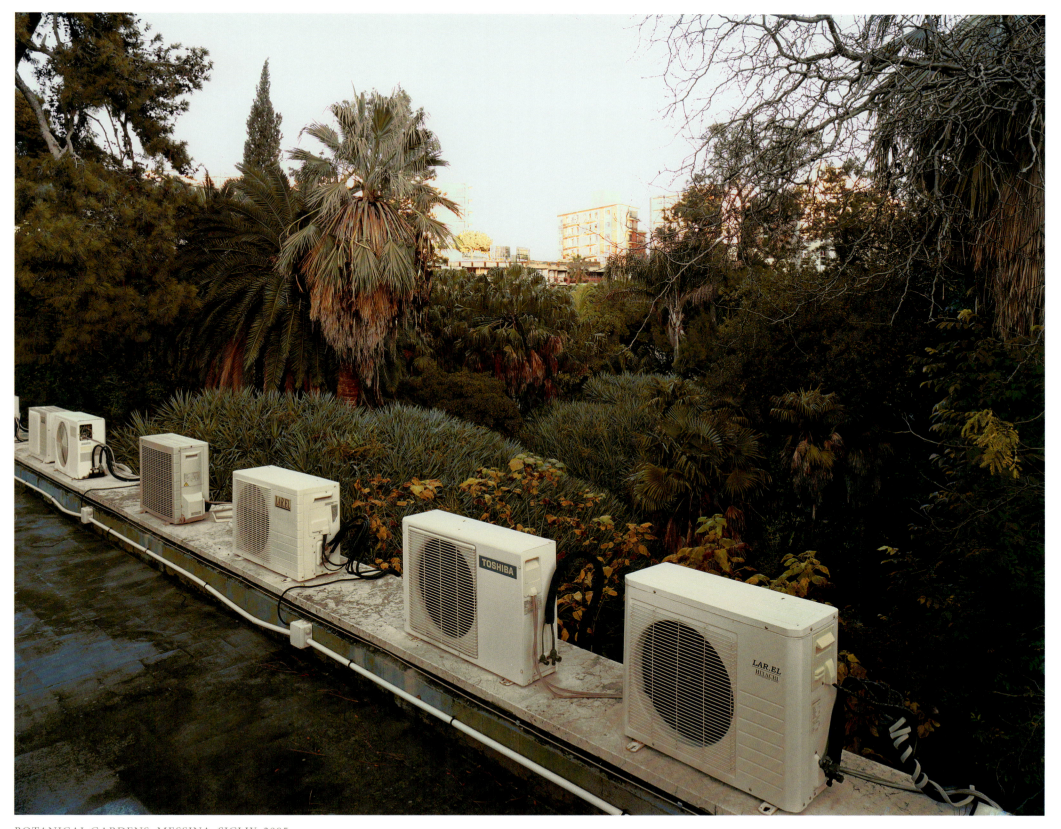

BOTANICAL GARDENS. MESSINA, SICLIY, 2005.

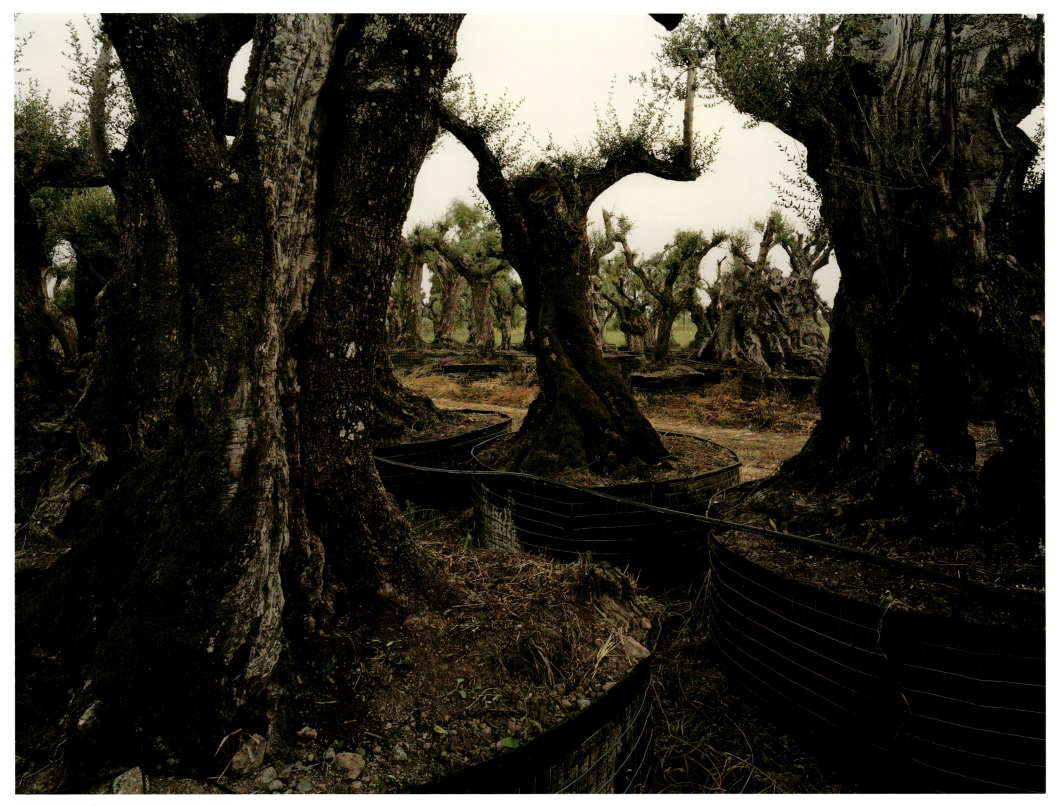

OLIVE TREE SALES LOT. LAZIO, 2007.

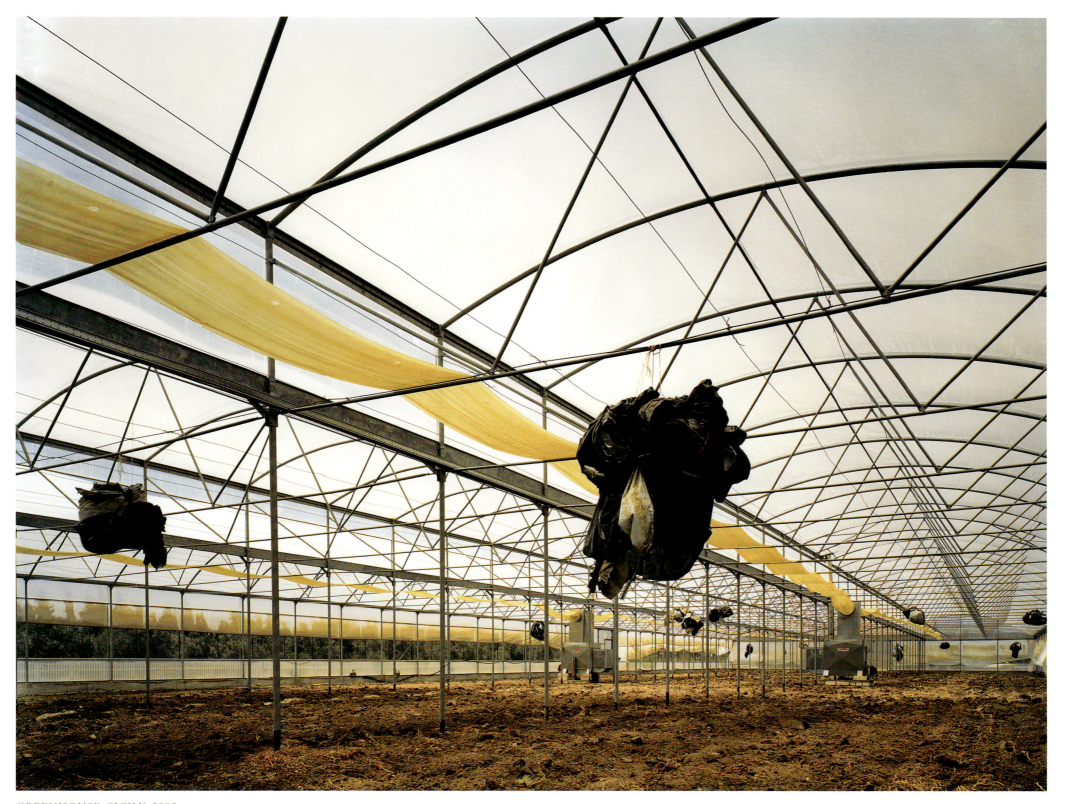

GREENHOUSE. SICILY, 2002.

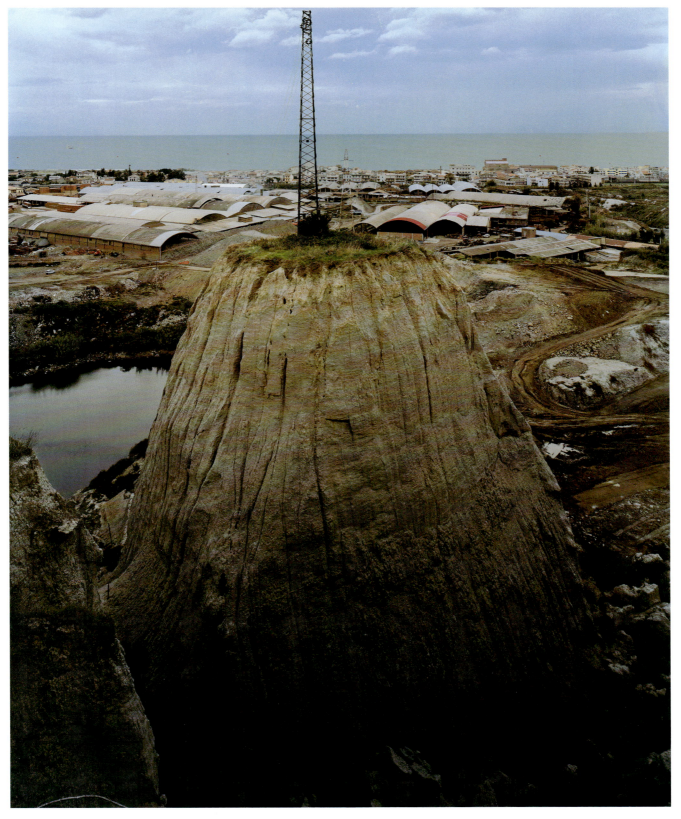

QUARRIED HILL. VALDINA, SICILY, 2005.

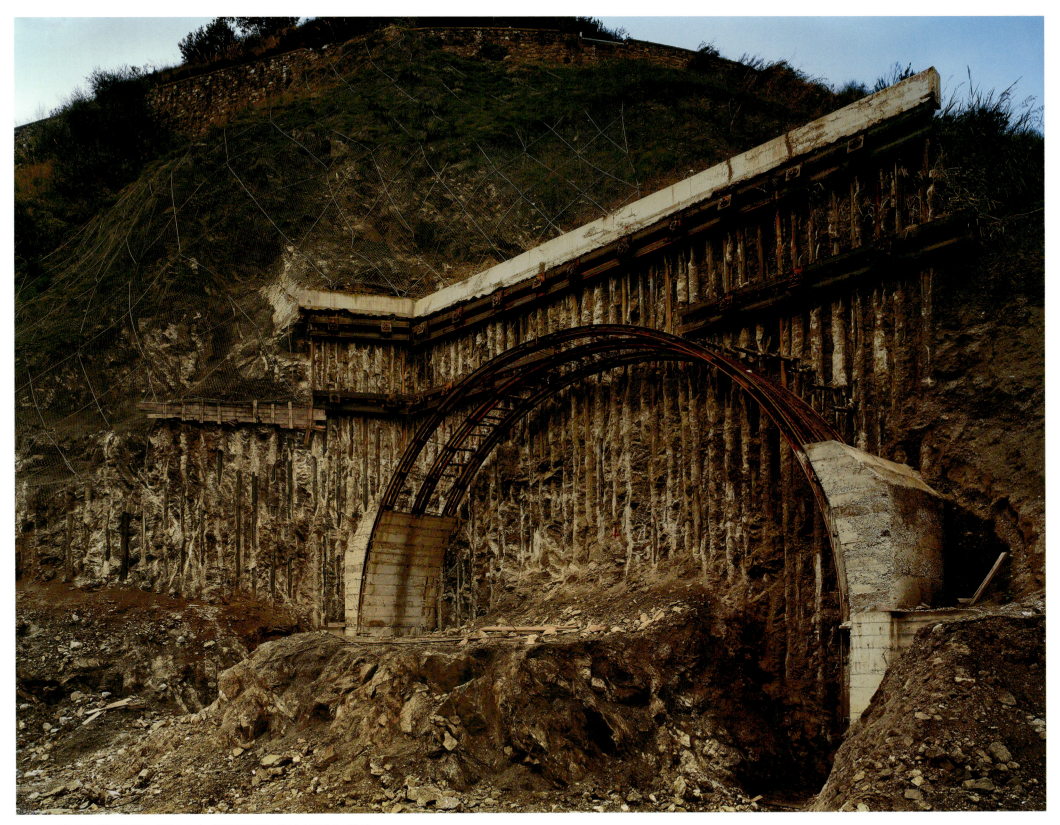

UNFINISHED TUNNEL. VILLA S. GIUSEPPE, CALABRIA, 2005.

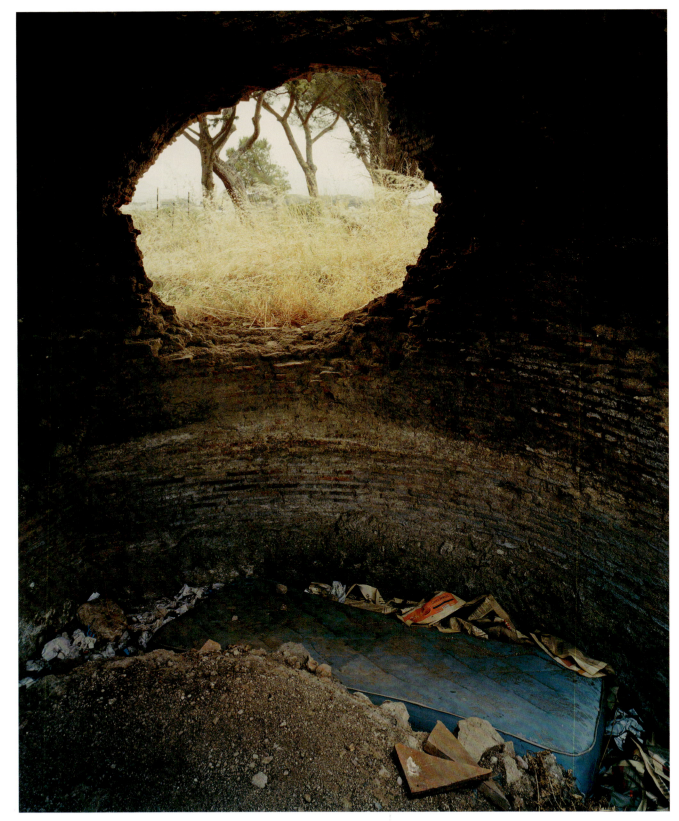

ROMAN MAUSOLEUM RUINS; MATTRESS. VIA APPIA, LAZIO, 2007.

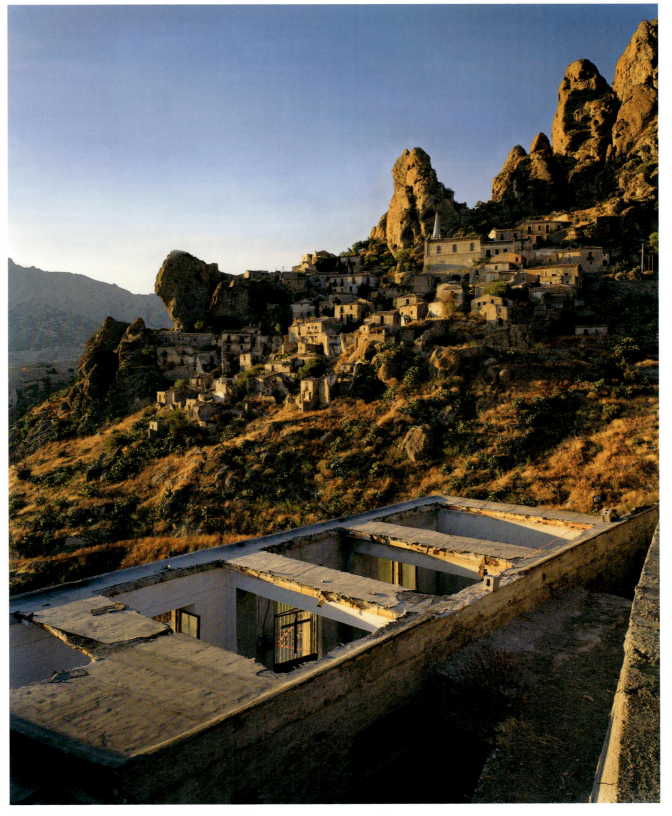

RUINS; PENTEDATTILO. CALABRIA, 2001.

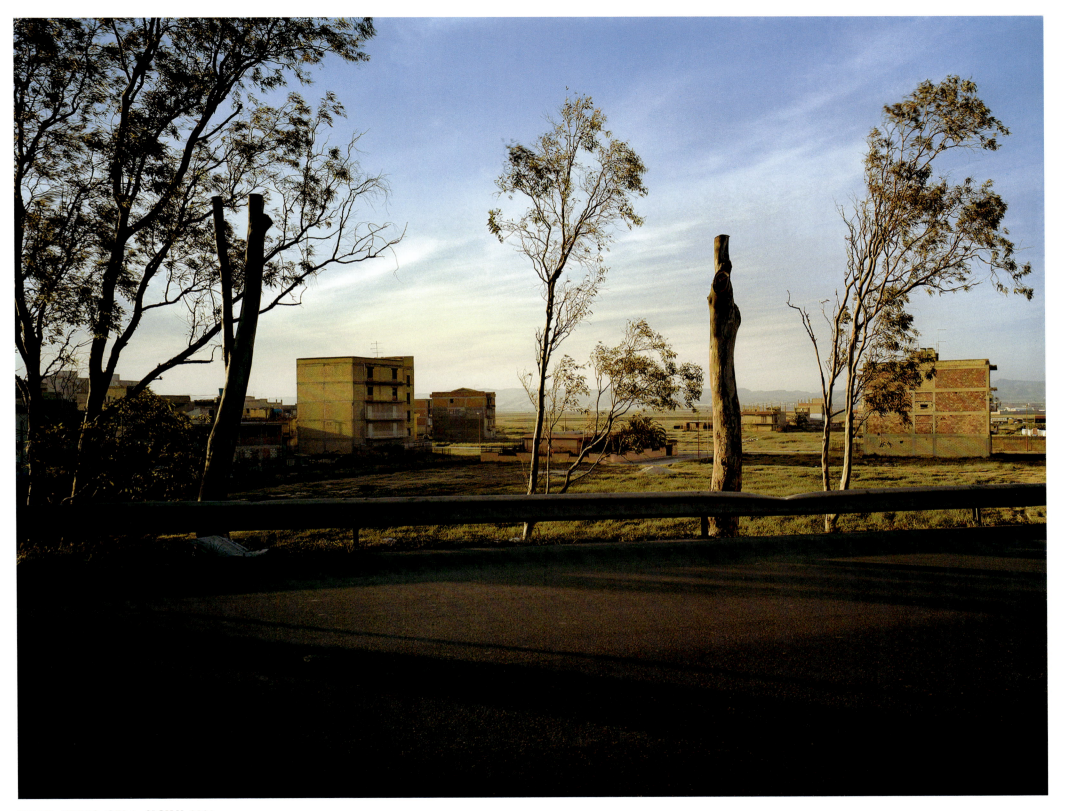

ROAD; TREES. GELA, SICILY, 2001.

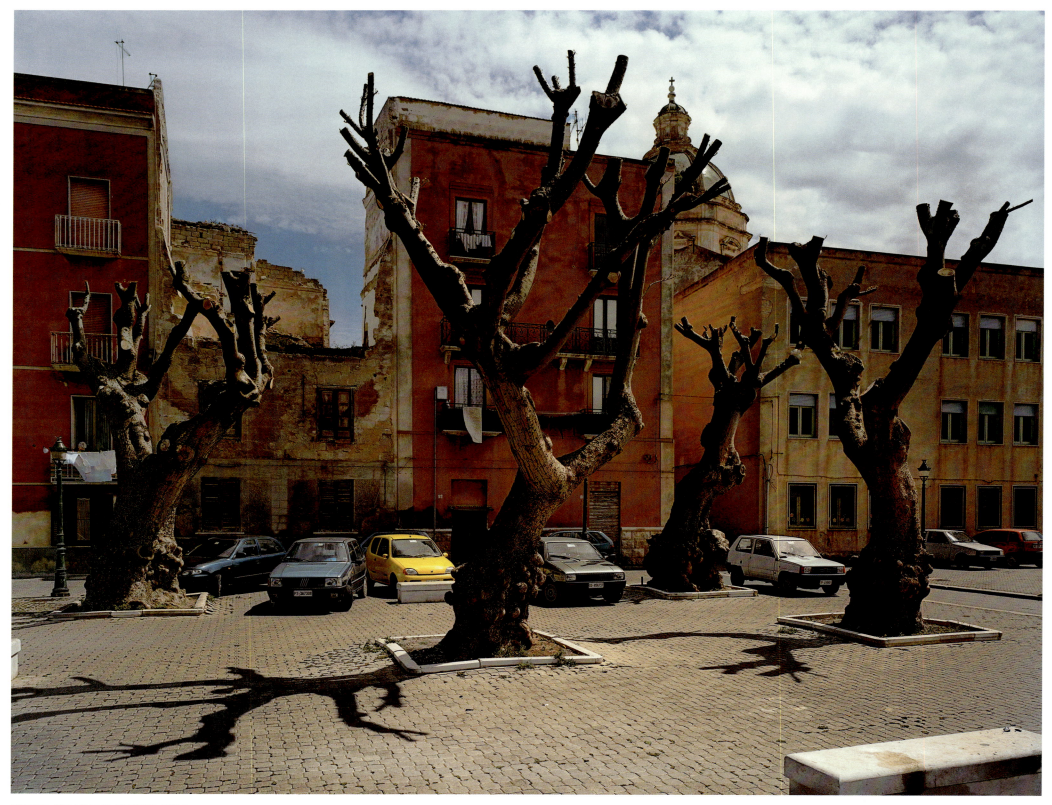

TREES; TRAPANI. SICILY, 2000.

26

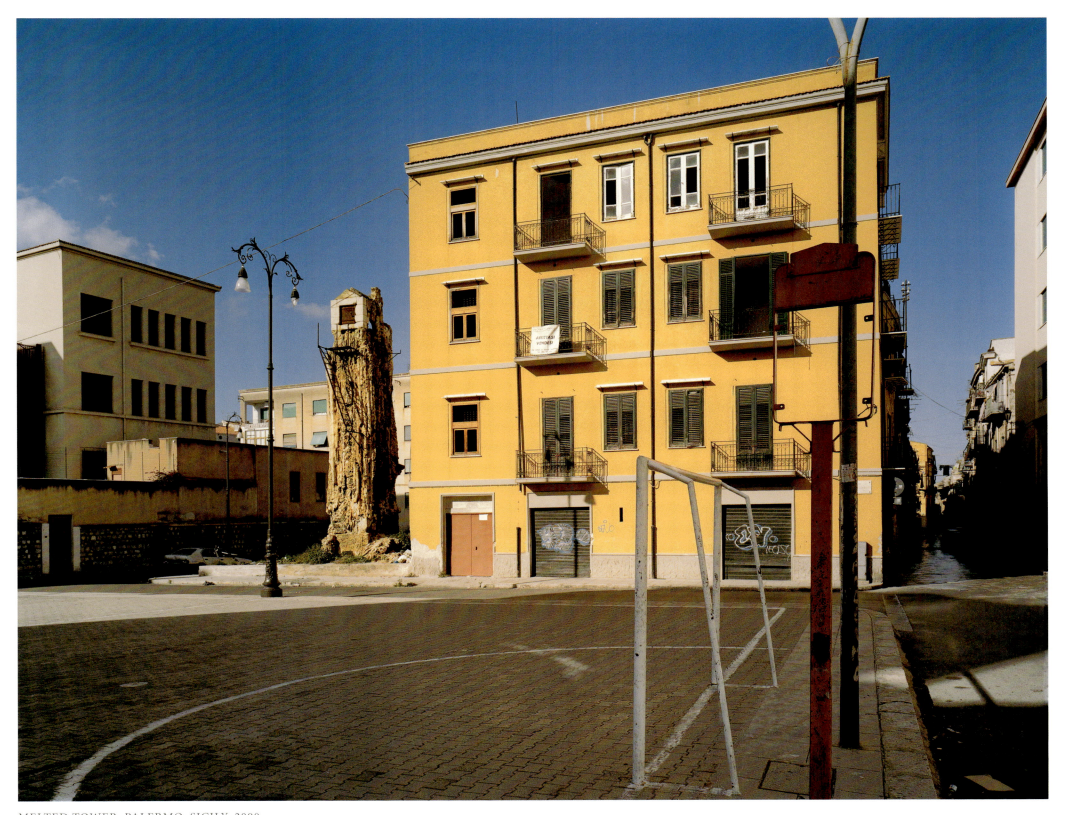

MELTED TOWER. PALERMO, SICILY, 2000.

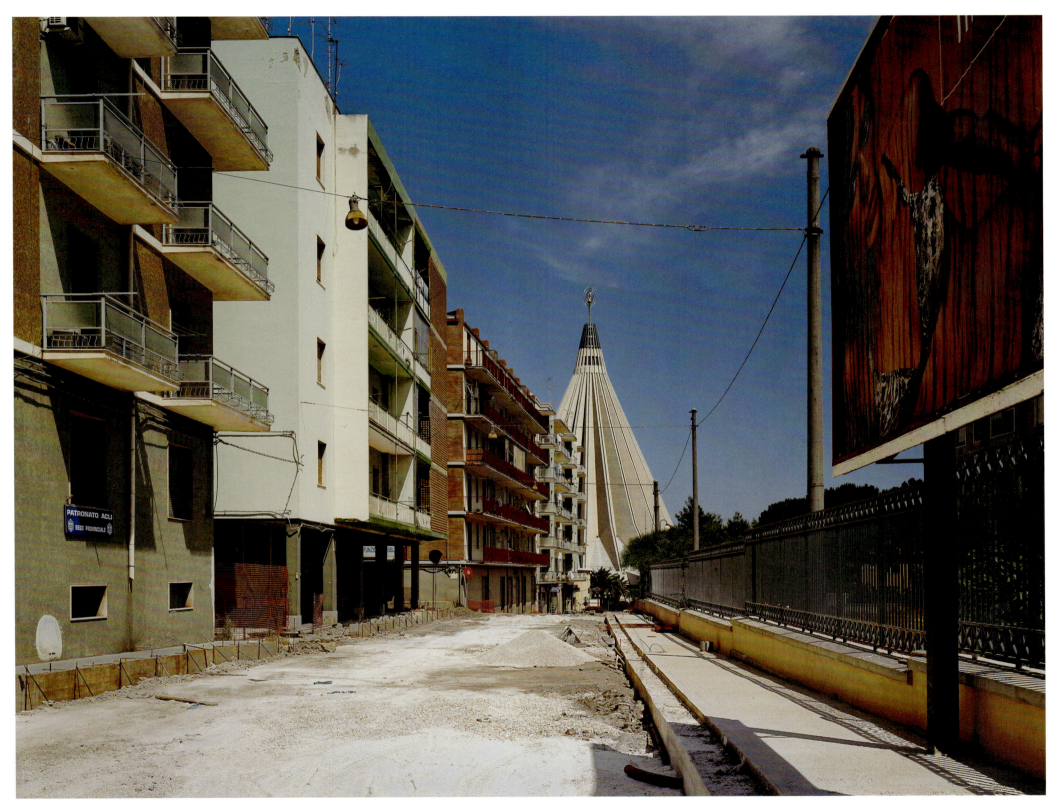

SANTUARIO MADONNA DELLE LACRIME; STREET. SIRACUSA, SICILY, 2002.

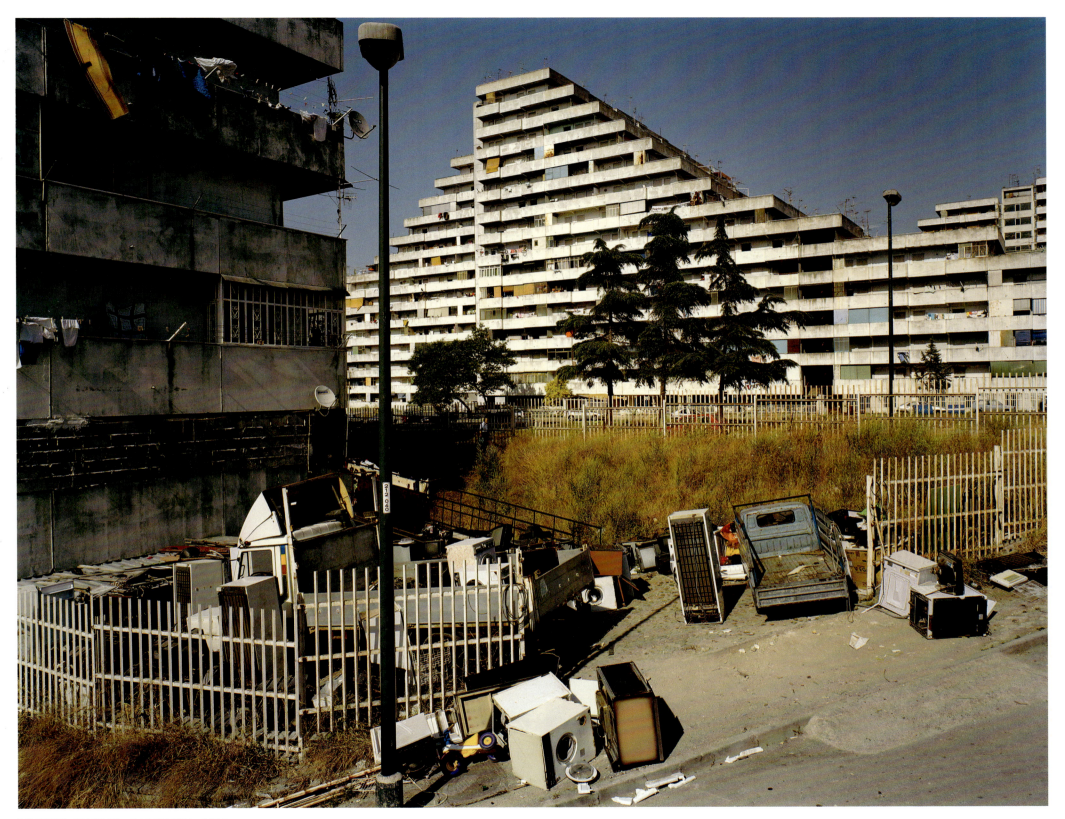

LE VELE. NAPLES, CAMPANIA, 2003.

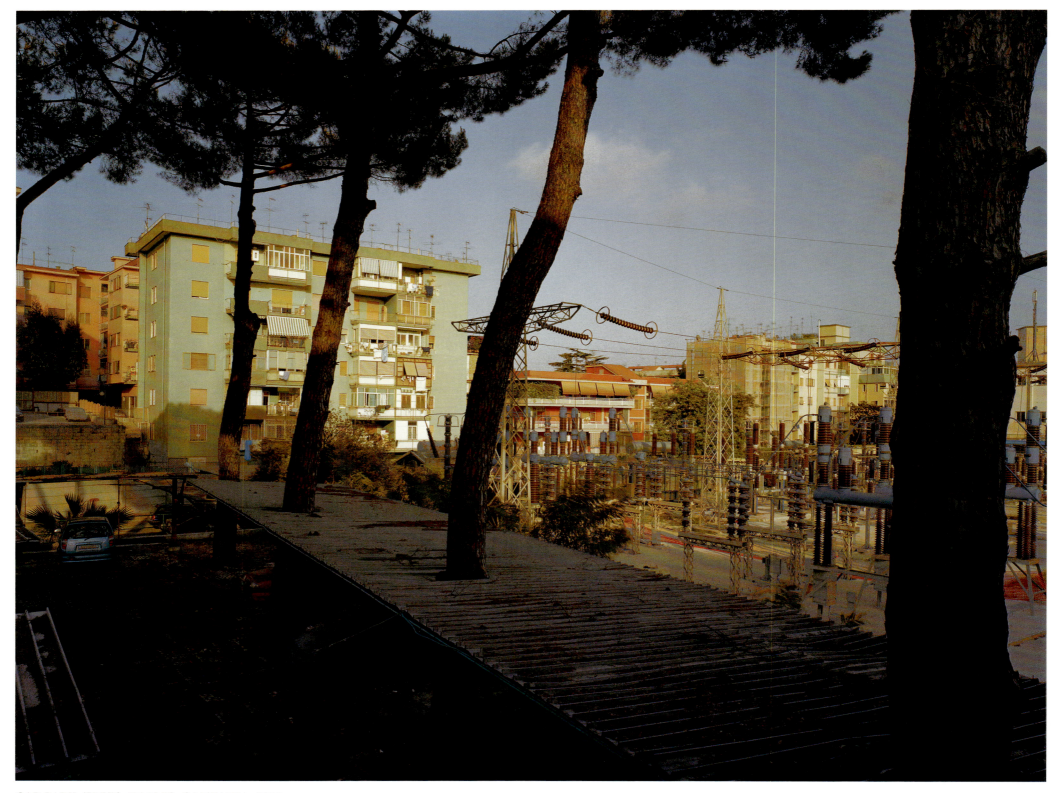

CAR PARK; TREES. NAPLES, CAMPANIA, 2003.

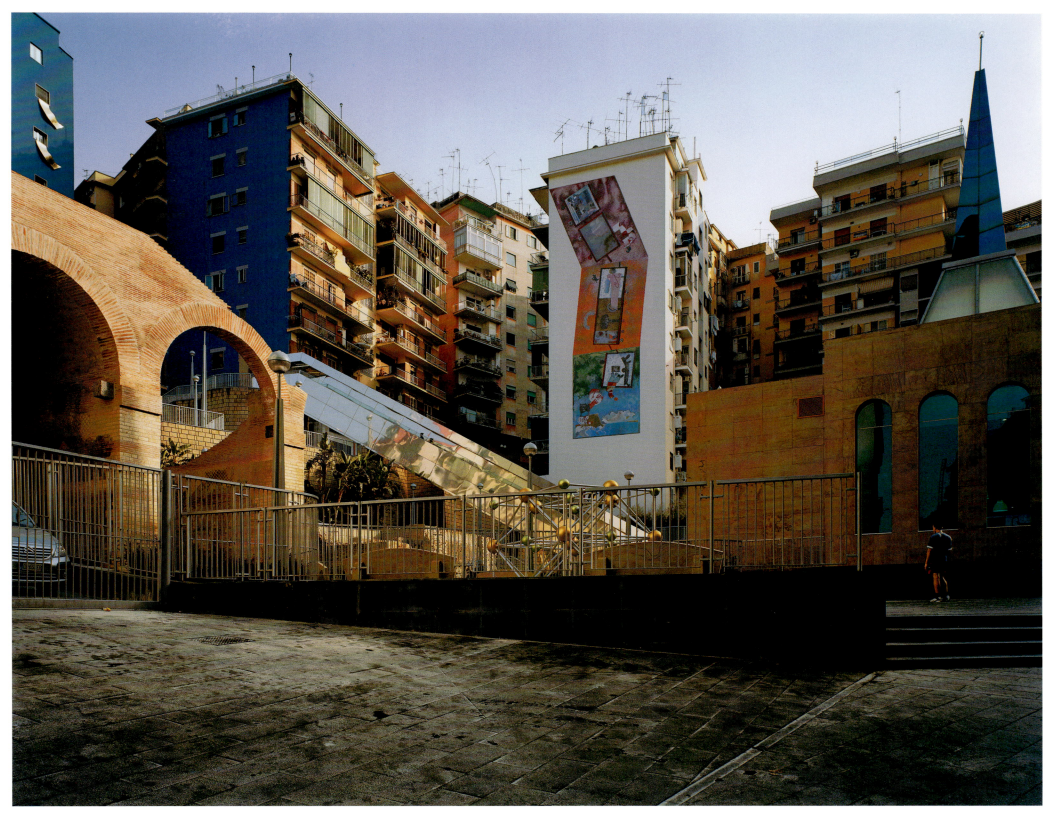

PIAZZA; METRO STATION. NAPLES, CAMPANIA, 2003.

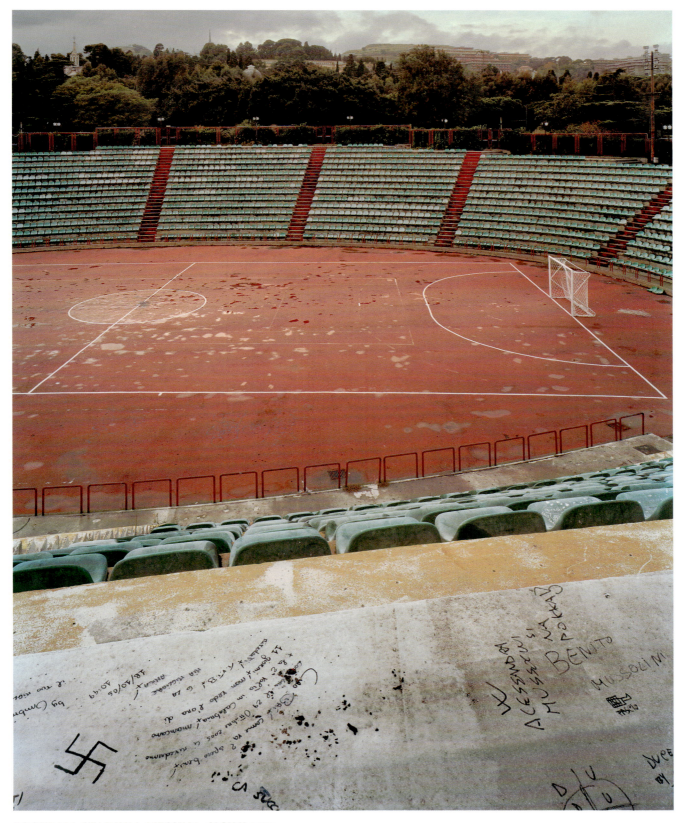

FOOTBALL STADIUM. MESSINA, SICILY 2005.

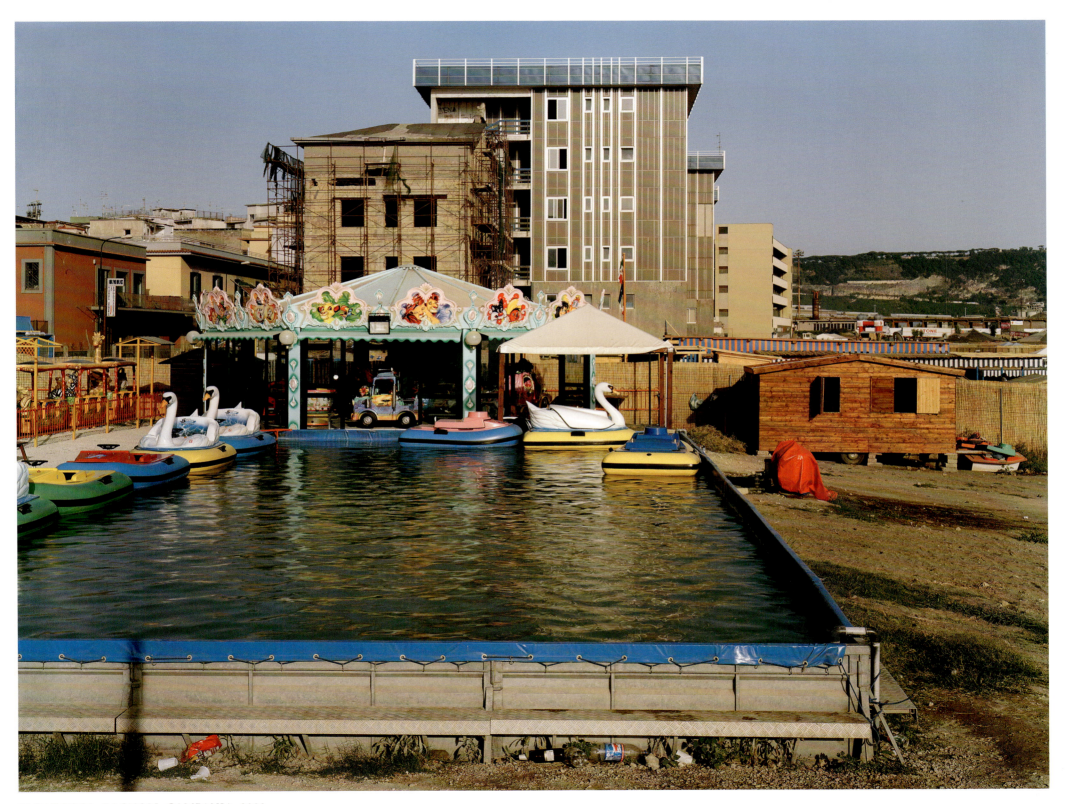

FLOAT POOL. BAGNOLI, CAMPANIA, 2000.

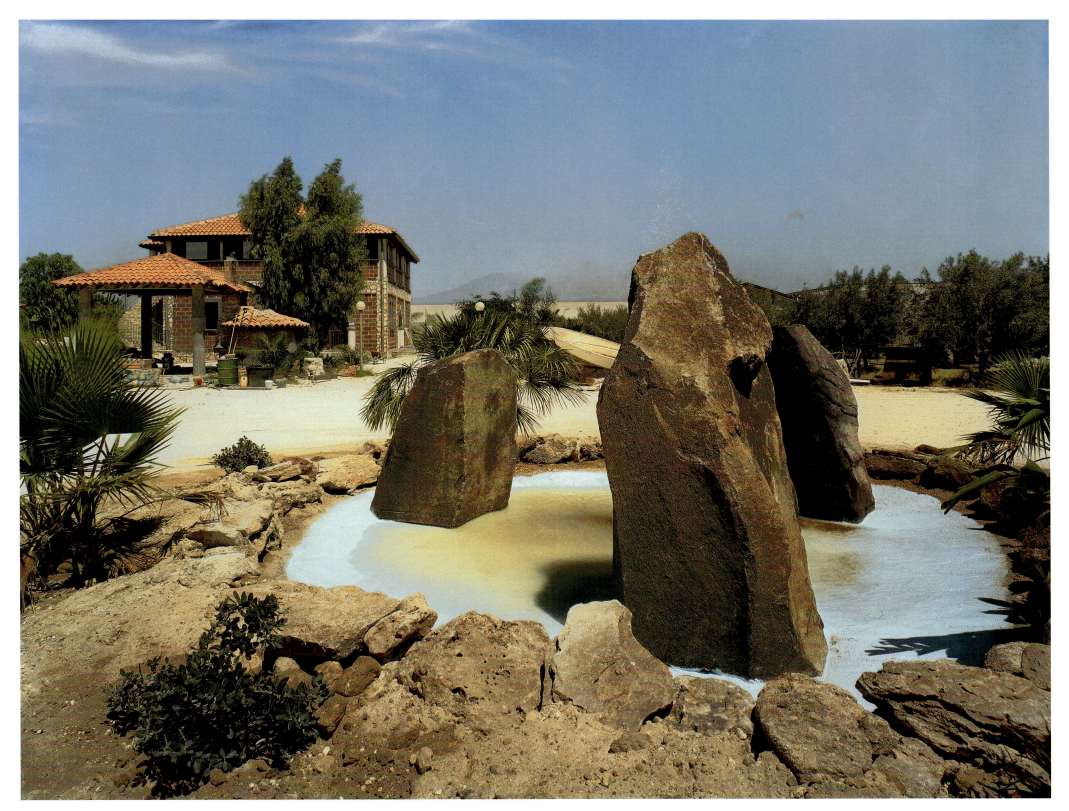

UNFINISHED BED AND BREAKFAST. SICILY, 2002.

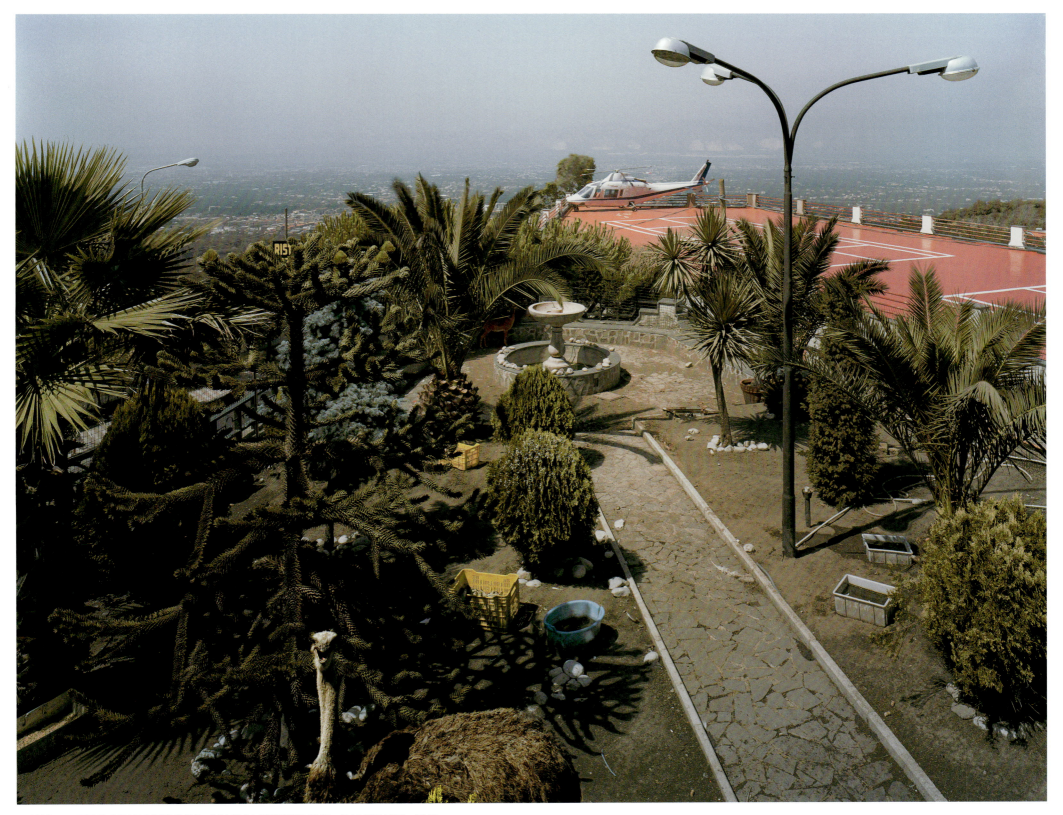

RISTORANTE ROSE ROSSE ZOO. SOMMA VESUVIANA, CAMPANIA, 2000.

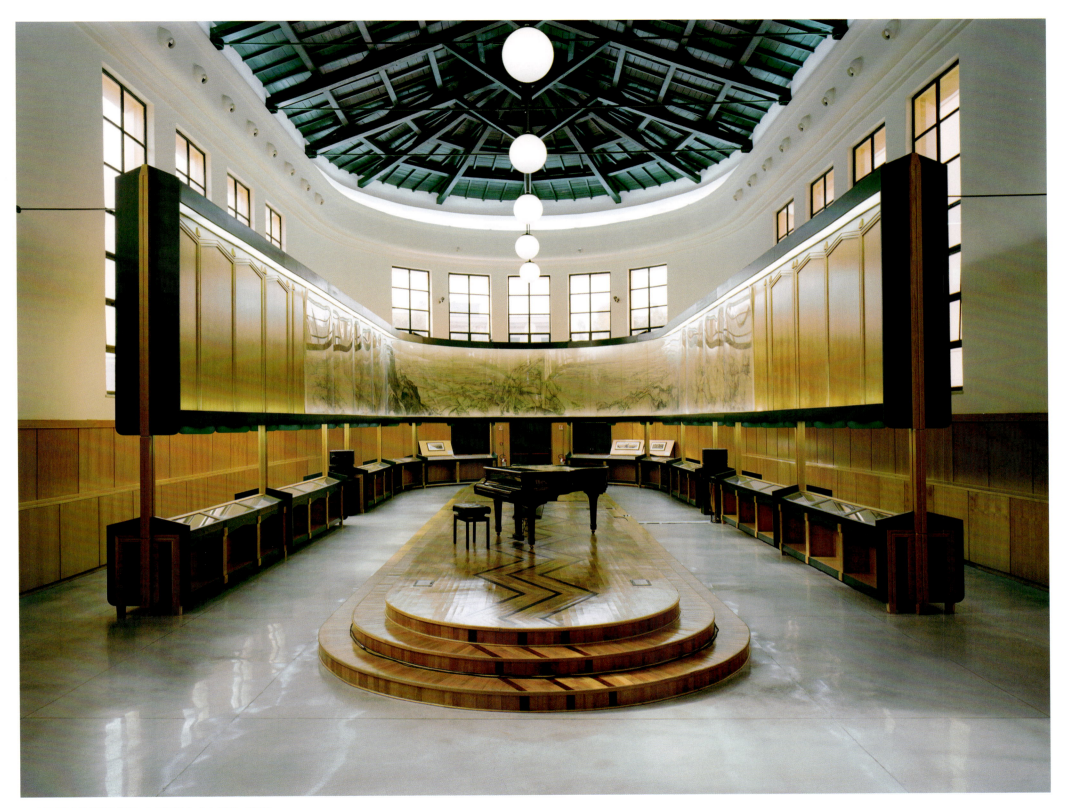

MUSEUM INTERIOR. LATINA, LAZIO, 2007.

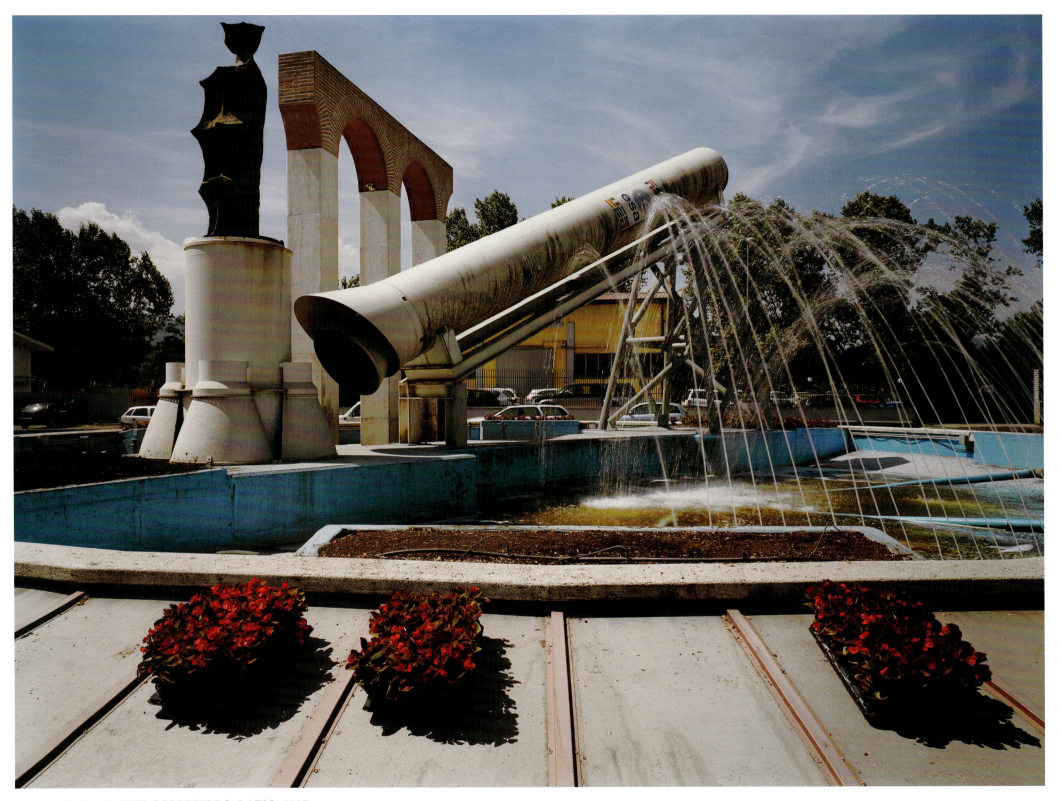

ROCKET MONUMENT. COLLEFERRO, LAZIO, 2007.

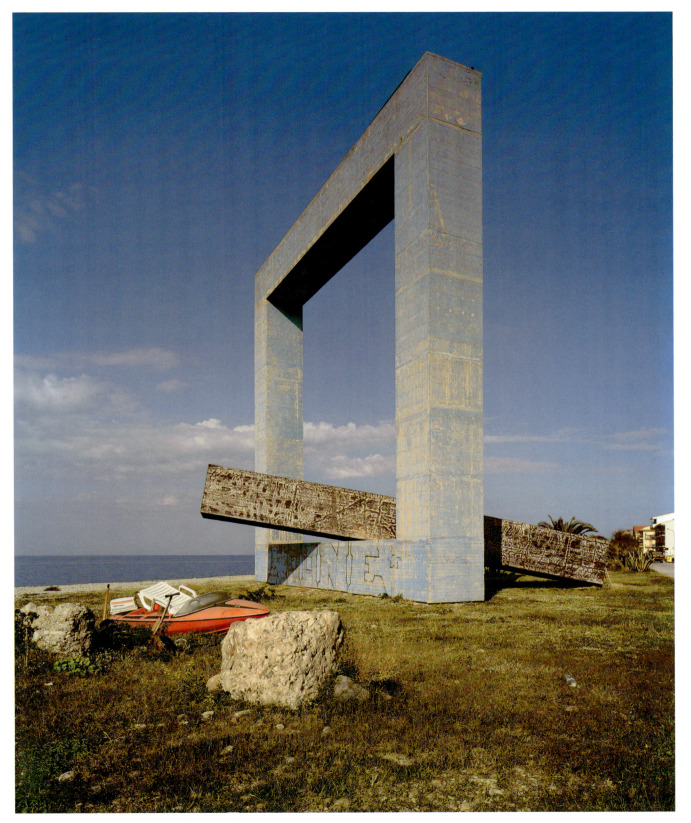

FINESTRA SUL MARE. S. STEFANO, SICILY, 2005.

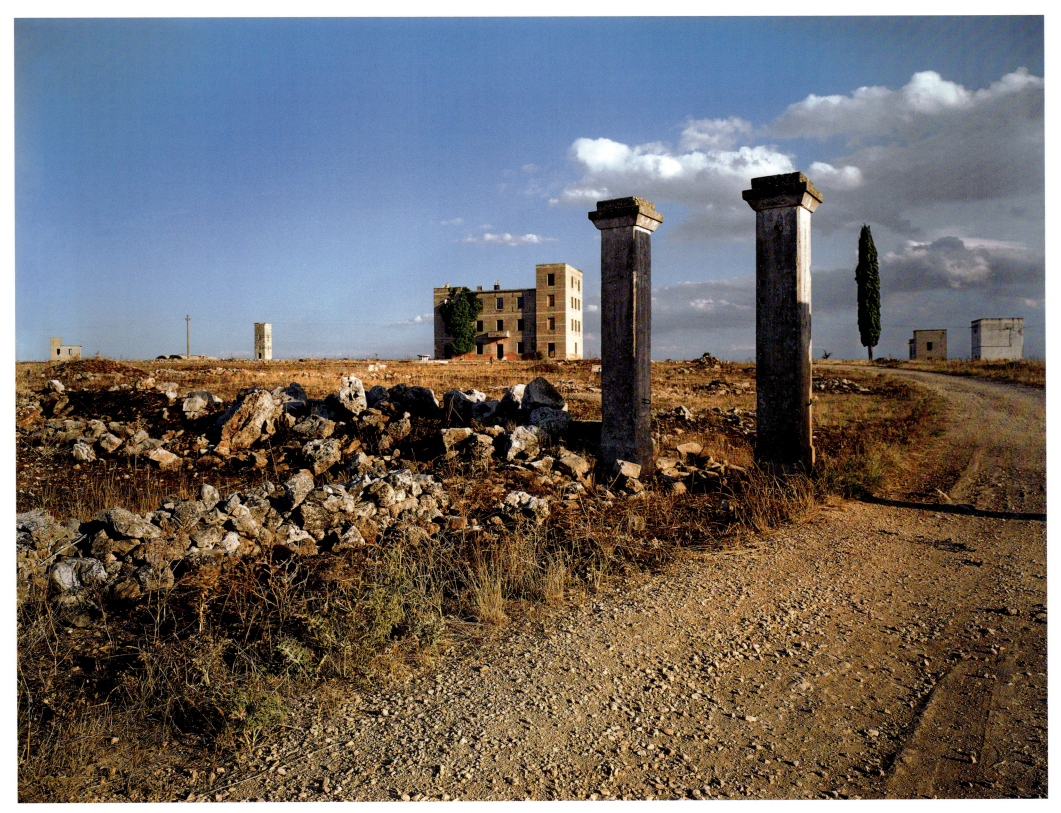

ABANDONED WORLD WAR II MILITARY BASE. PUGLIA, 2000.

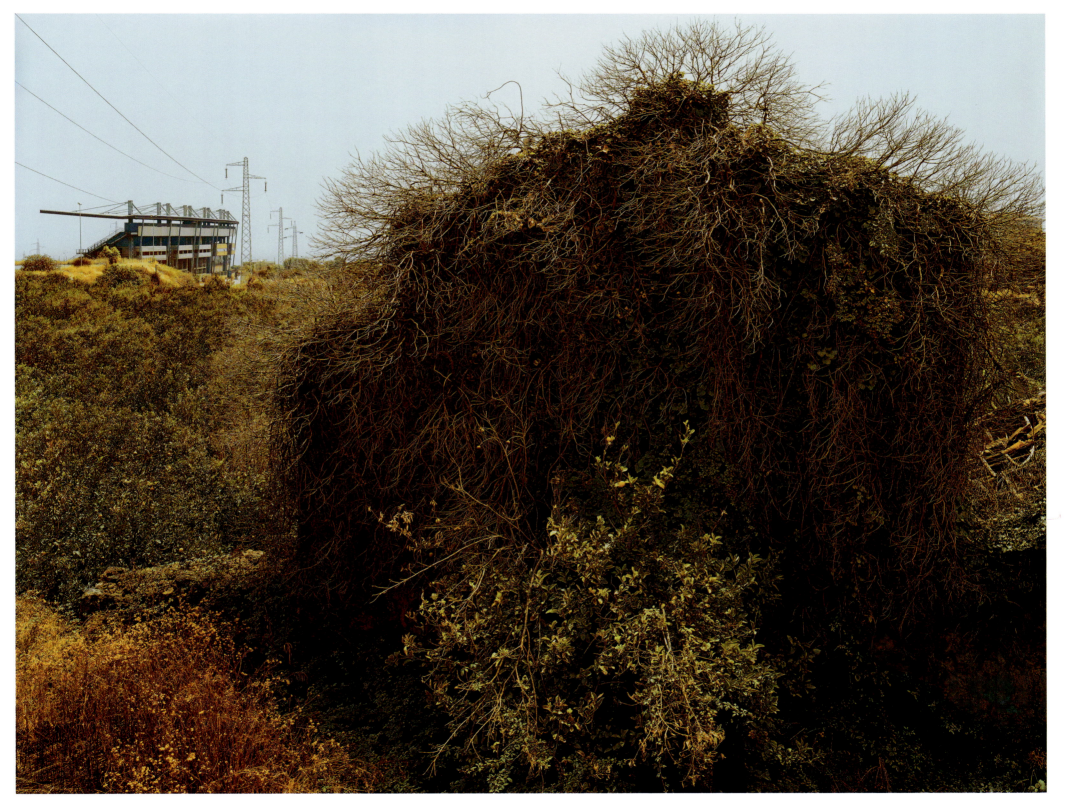

OVERGROWN BUILDING. ACIREALE, SICILY, 2002.

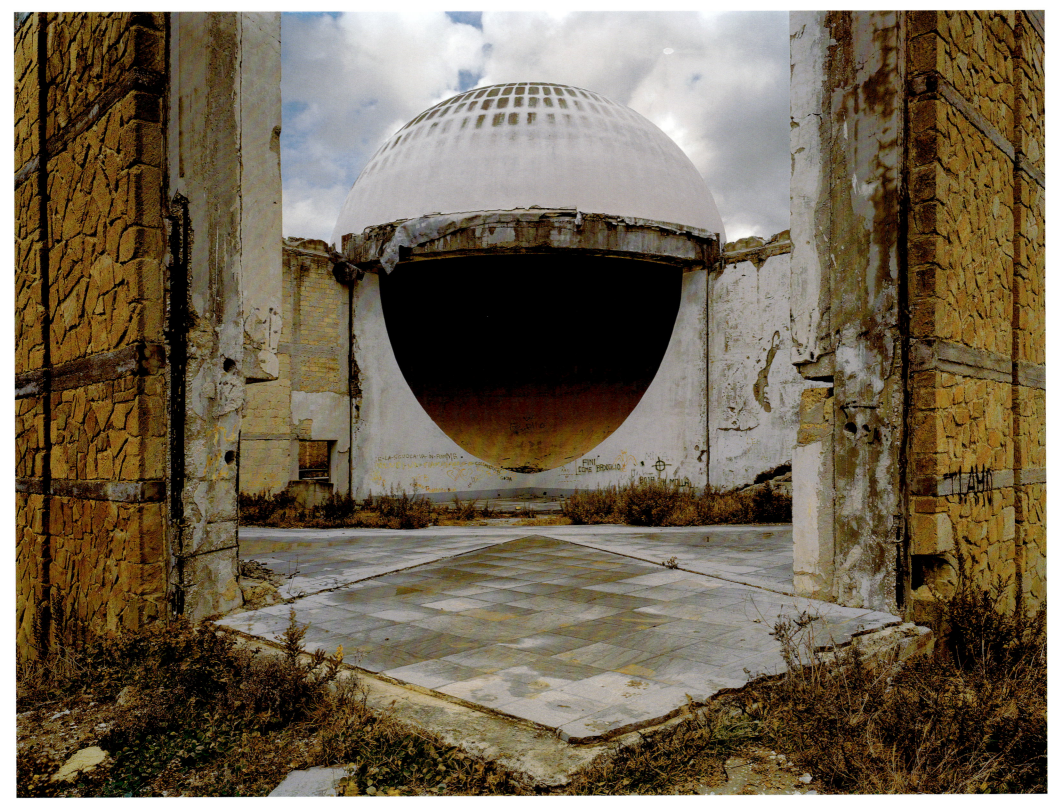

UNFINISHED CHURCH. GIBELLINA NUOVA, SICILY, 2005.

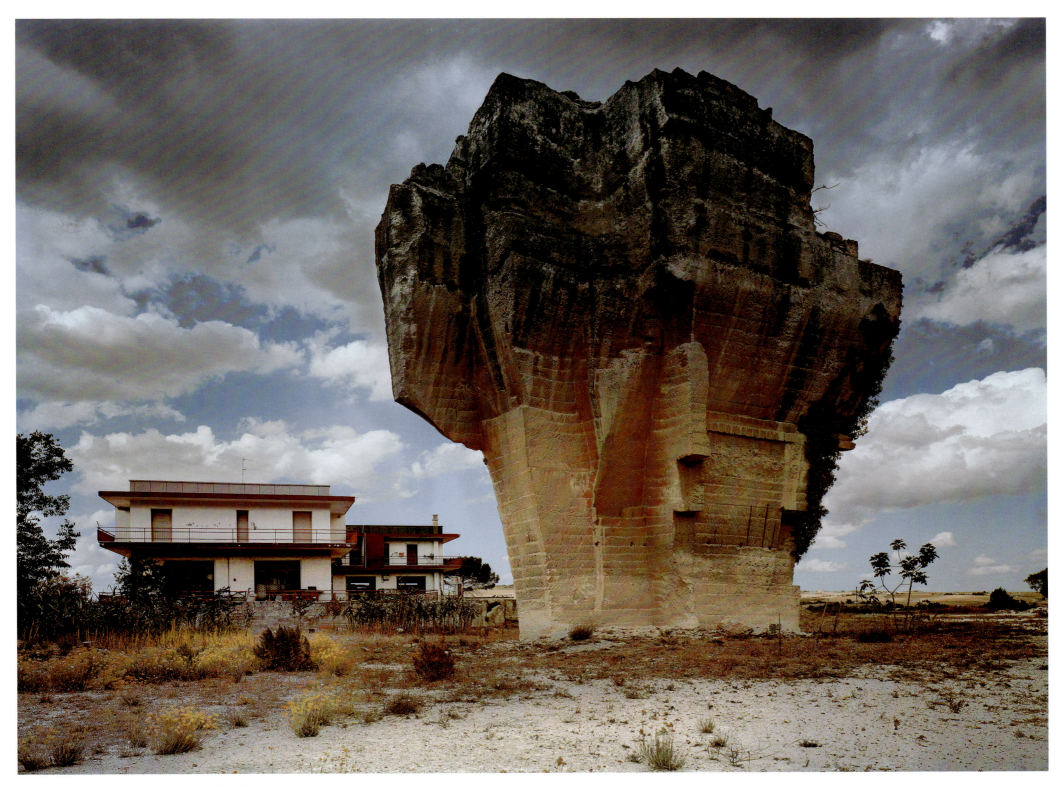

QUARRIED HILL. MATERA, BASILICATA, 2000.

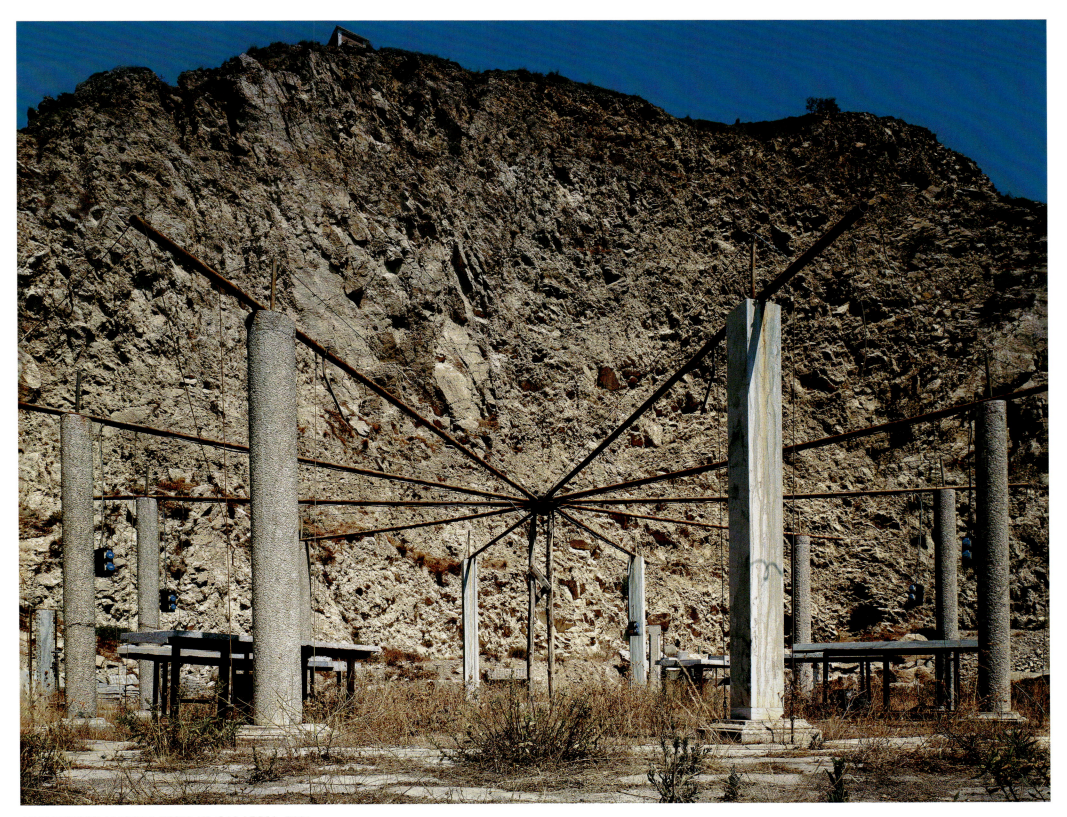

ABANDONED MARBLE DISPLAY. CALABRIA, 2001.

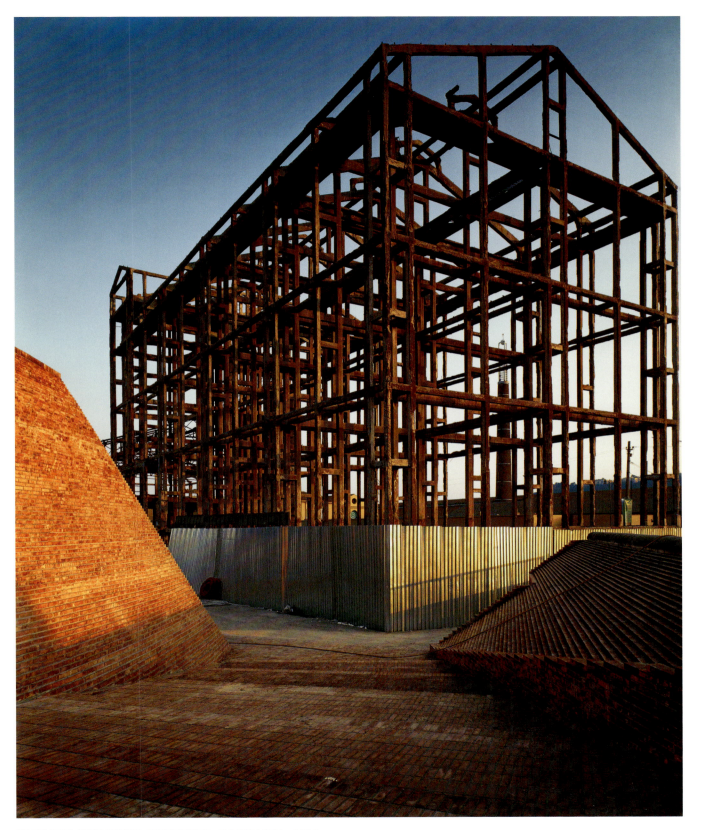

FACTORY SKELETON. POZZUOLI, CAMPANIA, 2003.

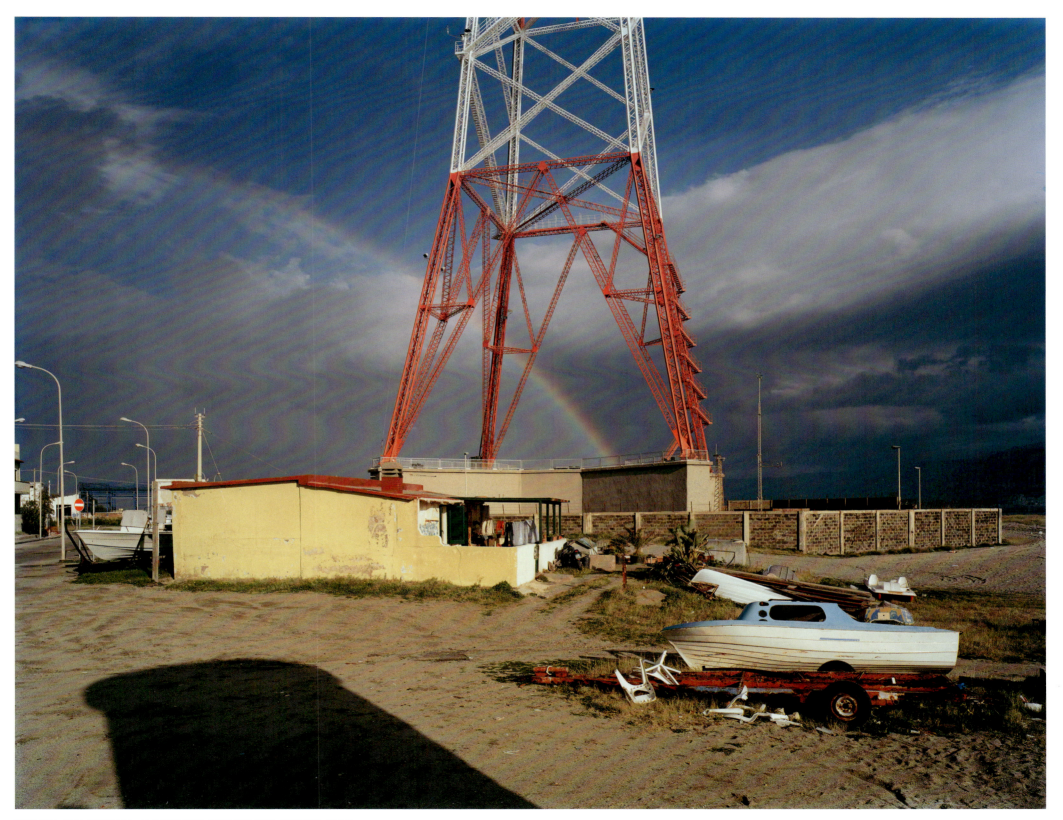

PYLON OF MESSINA; RAINBOW. SORGENTE, SICILY, 2005.

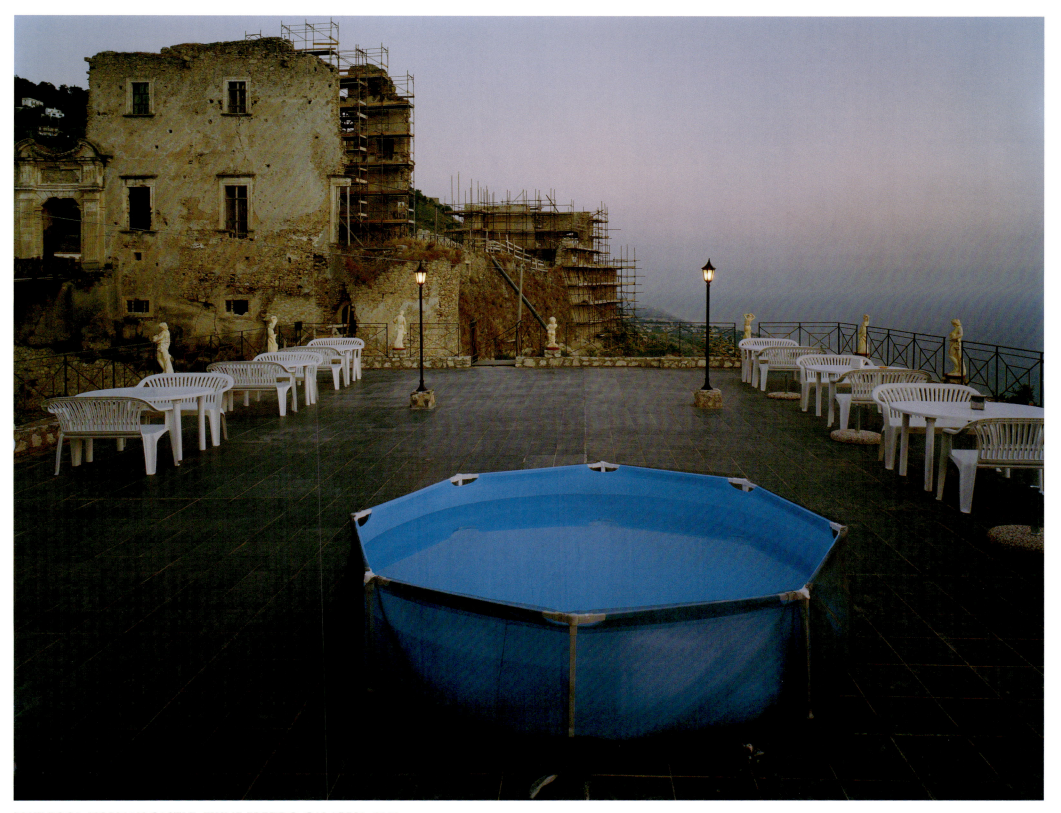

BLUE POOL; NORMAN CASTLE. FIUME FREDDO, CALABRIA, 2001.

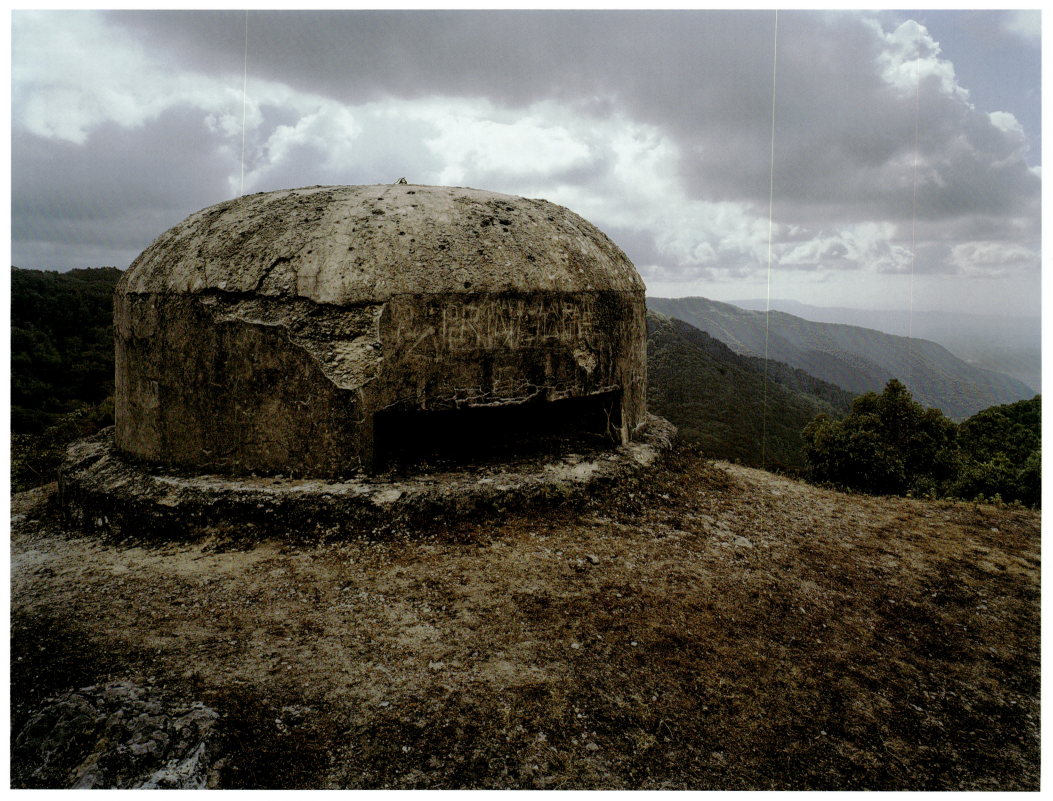

WORLD WAR II BUNKER. ASPROMONTE, CALABRIA, 2001.

MILITARY TRENCH. SICILY, 2005.

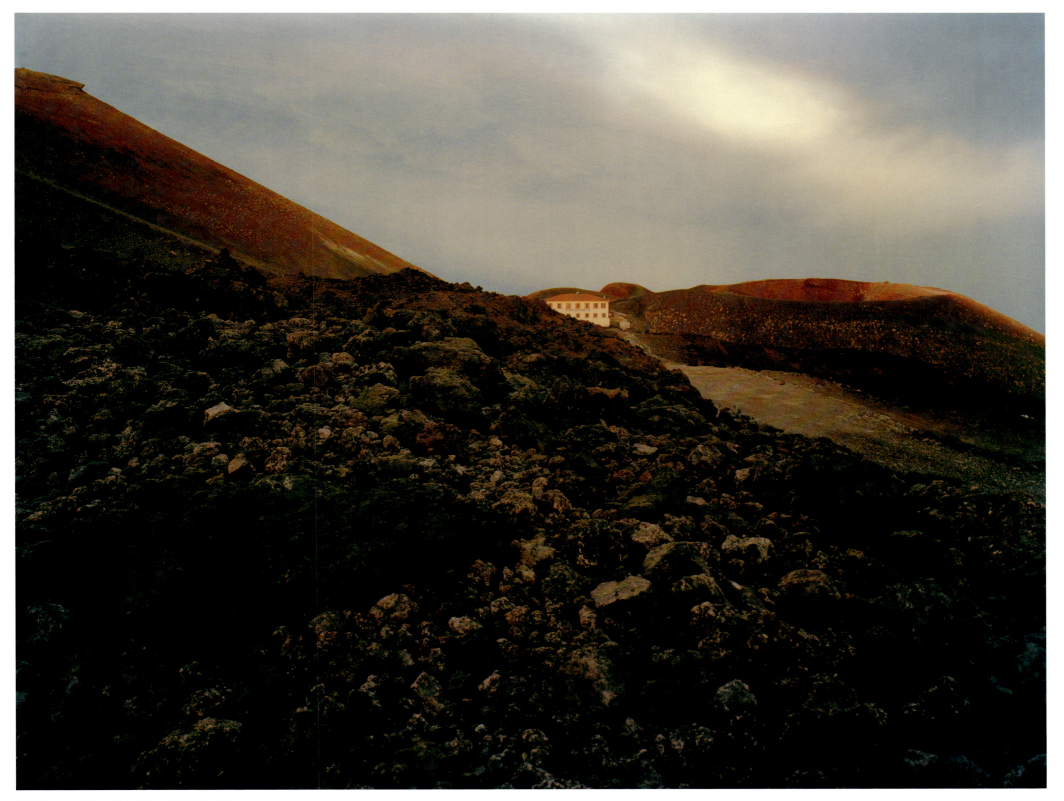

RISTORANTE. MT. ETNA, SICILY, 2002.

Working in the Field

By Tom Bamberger

Frederick Edwin Church hoped that Alexander Von Humboldt, the great German naturalist, would see his painting, *The Heart of Andes* (1859), as "a transcript of the scenery which delighted [von Humboldt's] eyes sixty years ago—and which he had pronounced to be the finest in the world."[1] The long march to achieve realism—the belief that a picture could resolve the character of its subject—was complete by the middle of the nineteenth century. But, unlike painting, photographs obeyed the laws of physics and seemed to be facts of nature. The camera "captured" the moment so we, the viewers, might wander in both time and place. Photographs fix reality.

But what is a photograph? Photography became a question that turned into an argument about perception, cognition, and reality. Modern art proceeded to demonstrate that realism is not a one-way street to reality. The twentieth century demoted photographs from veritable truths to mere propositions, if for no other reason than it became clear that any picture contains only a share of an infinitely larger story. The manifest objectivity of the medium became the perfect instrument with which to realize the potential subjectivity

of knowledge. For every photograph, one can advance an inexhaustible number of truths, each with equal justification. This skepticism became fuel for Postmodernism. A photograph became an inquiry into instability and contingency of knowledge.

Though there is no way to innocently frame a picture, photographers continue to believe in the relative transparency of the medium. Jay Wolke is part of a tradition running through Eugene Atget, Walker Evans, the new topographers of the 1970s, and members of the Dusseldorf School, each of whom wrestled with the conundrums of representation, photography, and art. The so-called "direct" Modernist approach quickly broke down romantic idealizations of nature into fragments. Photographers abolished the halos around their subjects. Each generation refined the grammar to eliminate affectations that inevitably cropped up.

As John Szarkowski remarked, the idea was to "let a photograph be a photograph." This obviously did not settle the issue—it's a tautology that started an exploratory process. There is no easy way to find the front door into a picture. There are innumerable possible truths to sift through in the layers of edifices and landscape alterations that fill the frame of Wolke's large-format camera. It is a slow intuitive process of excavation, construction, reflection, distillation, and conviction to get it right. If one photograph can be more convincing than another, then one pretense may be better than another. Wallace Stevens famously said, "The final belief is to believe in a fiction, which you know to be a fiction, there being nothing else. The exquisite truth is to know that it is a fiction and that you believe in it willingly."[3] Art paves the way to the middle ground between truth and skepticism.

It has been two decades since Wolke's last book, *Along the Divide*, which followed an expressway that unraveled the logic of his hometown. Incorporated in 1837, Chicago grew out of an Indian village on a flat marshy plain. The worst thing that ever happened, the Great Fire of 1871, renewed the city that became the site of the first steel-skeleton skyscraper in 1885. Chicago is in the heartland of America that never looked back while it bounded into the future. Wolke's freeway is a purposeful and reversible disruption to the fabric of an adolescent city.

In contrast, *The Architecture of Resignation* is a landscape continuously occupied for more than 2500 years. Il mezzogiorno (southern Italy) and Sicily are the stepping stones of the Mediterranean, connecting western Europe to the Far East and Africa. In the seafaring ancient world it was a busy intersection for the Phoenicians, Romans, Vandals, Muslims, and Normans whose architectural carcasses mark the battlefields of history. Wolke's new pictures span several divides — between man and nature, between eras and empires. Time is long in Italy. Disruption and happenstance in the mezzogiorno is not the exception, but the rule. The subject and photographer have matured together.

<div align="center">～</div>

In *Quarried Hill, Matera* (page 55) a monumental hunk of stone looms over us and a solitary house cowers in the background. The bottom of the stone has been whittled away into a trunk, like the last tree standing in a forest. Despite appearances, this is not a geological formation, and yet the rock marks time—the time it took humans to create it. Human and geological time converge again in *Quarried Hill*, Valdina (page 19). The oddity of a towering cone of earth crowned by a patch of grass and radio tower suggests the ambiguity of an industrial form and an inadvertent monumental work of land art. In reality, the cone is the chewed spine of a raped and pillaged mountain. Such despoliation is an unmediated ecological disaster unless you are willing to accept, in your heart, that humans are part of nature. From any point of view this earthwork is a fantastic subject. Wolke looks down on this remnant lording over a seaside hamlet. His sculptural subjects illustrate an emphatic statement elaborated in the rest of the book: "Look at what we have done."

Abandoned marble display (page 57) is a skeletal structure of circular pillars supporting a rusted metal frame before the face of a raw rock cliff. Neither the structure nor the rock face is contained within the picture frame, which serves to flatten the image and confuse the narrative. Was the rock face naturally eroded or gnawed at by a machine? Was the building abandoned during construction or is it finished? Wolke's landscapes are littered with desertions. A concrete bunker, a remnant of World War II, is strategically perched at the apex of a hill overlooking a long river valley. In

the foreground of another photograph a contemporary house lies in ruins beneath the ancient Greek city of Pentedattilo (page 23). And then there is an image picture of nature completely encompassing a small building in the Sicilian landscape (*Overgrown Building*, page 51).

One might think that sculpture would find a comfortable home in this surreal landscape. *Finestra sul Mare*, or window on the sea, (page 47) by Tano Festa (1938–1988), a prominent Italian artist, is a massive minimalist work made up of a blue concrete rectangular frame pierced by a long black pillar tipped into it and pointing out to sea. After the sun and salt etched the black into a brown-white graphic pattern and bleached the blue to a faint transparent wash, Finestra sul Mare was declared both a health and moral hazard by those who live nearby. Nothing the oddities of the narrative twisted by the ironies of history.

In *Via Appia end* (p ii), the city has grown up around a Roman column, which has been encased in steel-framed glass panels to preserve it. The walls, no doubt a protective measure, now wear the graffiti once applied to the antiquity. In Wolke's picture, the steel supports bisect the picture and leave just a few inches of space in which to clearly see the pillar. The photographer pushes our nose right on the glass, floating the graffiti onto another plane, breaking time into perceptual layers that drift away from the scene into consciousness.

Wolke's urban pictures follow the fault lines between the past and the present. In *Messina Pool; Arabesque* the scene emerges from an empty

marble pool marked by neglect save for a sweetly domestic row of potted cacti (page 69). A much larger building appears to be under construction across the small courtyard from a Moorish revival villa; yet its fate is unknown. In *Piazza; Metro Station* (page 33) the scene is suspended in aimless time. New buildings seem to be an afterthought—a work-around by some force outside of the frame. A metro station crowned by a church steeple lies next to a sculpture that looks like a futuristic jungle gym and a gleaming escalator running up to the train track; all are wedged into an impenetrable and ragged housing development. A tall white wall with an illusionistic mural skews the scene in two. The rest is a riot of hues and shades of blue, green, and orange—an incomprehensible jumble laced together by art.

History swallows even the best intentions before their time. The ancient town of Gibellina was relocated in its entirety after a massive earthquake in 1968. The new city, Gibellina Nuova, was designed by some of the most prominent artists and architects in Italy as a "utopian village" bearing little architectural relation to the history of the Sicilian landscape. Wolke peers into a courtyard of some prominence in *Unfinished Church* (page 53). The exterior walls are clad in intricately carved stone; inside a domed structure is opened to the viewer. At first, this negative space might appear to be a shadow but the gradations of light create a boundless inversion. The contrast between solid and void is a fine marriage of two infinities—one bounded in classical form and the other unbounded by modernity. Like many of

Wolke's subjects, the project was unresolved. Today it is crumbling into a fanciful icon of utopia, a fictional civilization. The builders of Gibellina Nuova ran out of money—life is a ruin.

⤝

Yet it is impossible for Wolke to make a pessimistic picture. No one would make eleven trips across the world carrying a large-format camera, tripod, and film, chase the fleeting light, make hundreds and hundreds of exposures, then spend months scanning negatives and rebuilding images in Photoshop to produce a finely honed photographic sequence just to make a factual point about the world. Wolke wrestles with his photographs, despite his subject, to make us open our minds and eyes to see.

Jay Wolke's art makes an image more real than we may want it to be. Unlike the austere rectilinearity of contemporary landscape photography, which often detaches the viewer, he welds his subject to a taut and tense frame. Then, he plunges in. His work is full of blunt juxtapositions laced with nervy figure-ground relationships; his photographs are high-strung, with very little atmosphere to soften his pictures. Through his various strategies of composition and color, Wolke compresses the subject until its formal elements puncture the picture plane. As in the paintings of Henri Matisse, color competes with lines to define the volumes in Wolke's photographs. Subtle contrasts between warm and cool tones deepen the space. The

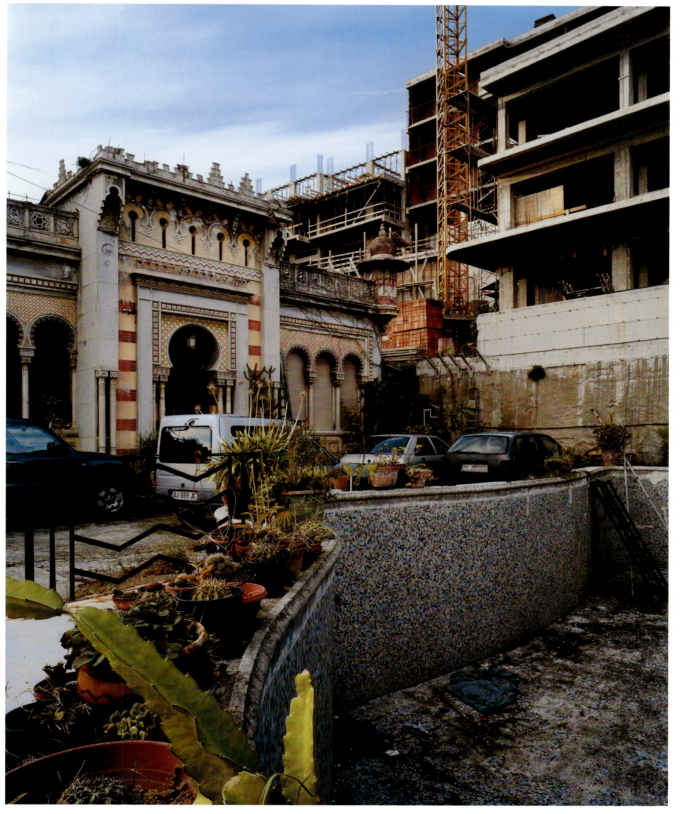

POOL; ARABESQUE. MESSINA, SICILY, 2005.

richness of the palette and finely tuned textural elements slightly tip the photograph into our mind's eye. The scene vibrates ever-so-slightly out of register. Beauty animates the photograph into a cognitive object instead of a mere reflection. It is often said that the nature of contemporary art is that you don't know what you are looking at. When Wolke gets lucky his pictures don't resolve anything. If we are lucky something stops us from seeing this worn out and beleaguered landscape in retrospect. Wolke is not telling us a story. His photographs are an instant when everything is new.

NOTES

1 Stephen Jay Gould, "Church, Humboldt, and Darwin: The Tension and Harmony of Art and Science" in *Latin American Popular Culture: An Introduction* (New York: Rowman & Littlefield, 2000), 27–42.

2 Richard Rorty, *Consequences of Pragmatism: Essays, 1972–1980* (Minneapolis: University of Minnesota Press, 1982), 25.

3 Wallace Stevens, *Opus Posthumous: Poems, Plays, Prose* (New York: Knopf, 1957), 189.

Architecture
of Resignation

by Jay Wolke

In 550 BC, construction began on one of the most massive temples ever imagined in the Greek world. Today, visitors to Selinunte in southwestern Sicily roam the scattered mass of fragments, which is now known as Temple G or sometimes the Temple of Hera. Imagining the temple in its once-towering majesty is a predictable behavior, but, in reality, the temple was unfinished when the Carthaginians destroyed Selinunte in 409 BC. Portions of the structure remain in the exact state of non-completion as they were then, reminders of a continuous cycle of conquer and occupation that have marred the landscape of southern Italy throughout the millennia.

In 2000, I began photographing in Sicily and extended my exploration northward, all the way to the outskirts of Rome. During the course of seven years, I witnessed the cultural complexity that is the *Mezzogiorno* and, through the making of photographs, my interrogations evolved into a set of images I now call *Architecture of Resignation*. What I found in the southern Italian and

Sicilian landscape is an elaborate set of physical, social, and political structures that form a palimpsest of visual information. On one level my photographs are referential and documentary; but on another level they are about what cannot be easily seen, what is hidden and implied. There are larger narratives of the marks made, marks abandoned, and marks erased, and they document numerous conquerors and occupiers from the Greeks and Romans to the Goths and Saracens to the Spanish and French to the Allies in World War II and the Catholic Church to the Mafia and even the Italian government itself. The resulting adaptations and resignations of the people to this dominance are evident, and represent a major portion of my photographic attention. Even when southern Italy was called the Kingdom of Naples or the Two Kingdoms of Sicily, the local administrators were authorized by other, foreign powers and were hugely influenced by local autocrats. Often, architecture and technology have been used as political smoke screens, hiding the much greater exchanges of power. With great promises of progress, the land has been exploited and parceled out for the convenience of a few and accepted with resignation and submission by the many.

My attention was initially piqued by the glut of incomplete and unoccupied building projects, but even as my path shifted toward the cultural dramas and ambiguities of Italy's South, I was still drawn to the numerous, peculiar aggregations. I mean this both as literal object and as metaphor. The Italian consumption of concrete in all its forms, stretching back to Roman times, is representative of so many dreams per square foot poured; the ambitious leftovers dotting the landscape with shapes of every sort, the incremental compression of the various dreams both past and present. As Tobias Jones wrote in *The Dark Heart of Italy*, "[Italy] has aged like someone who has lived life in the fast lane, someone who has. . . the lines and scars to prove it."[1] The very face of its social and political history is worn in the landscape of the South; Italians now must stare reflexively at their molested collective self.

My pictures tell stories that expose the rise and fall of various colonial, political, and commercial powers, as well as the inspired, but often faltering, efforts of ambitious individuals. My large-format, color images are meant to convey purposeful neutrality—compositions of selected non-fictions resonating with historical and contemporary meaning. These photographs are not meant to edify or memorialize. Some of the subjects aspire to greatness while others convey an uncanny indifference to their own fate. Some of the artifacts I've examined are more sculptural than architectural, in that they were never utilitarian, and at present communicate a sense of pervasive anachronism. The images represent the integrity (or the lack there of) of the systems being photographed and yet we view them through lenses colored by the timeless belief in the *bel paese* even as the place is layered in dysfunction and greed.

NOTE

1. Tobias Jones, *The Dark Heart of Italy* (New York: Faber and Faber Publishing, 2003), 212.

NOTES ON THE PLATES

FRONTISPIECE Via Appia end. Brindisi, Puglia, 2007. The ruins of two columns mark the terminus of the ancient Roman Via Appia at the Adriatic port of Brindisi. The columns served as a port marker for ancient mariners. After years of abuse and vandalism, the *commune* has erected successive barriers to protect the structures.

PAGE *vi* Blue piles; Abandoned factory. Termini Imerese, Sicily, 2005.

PAGE 3 Church; Palms. Marsala, Sicily, 2000.

PAGE 5 Church; Vans. Nizza di Sicilia, 2005.

PAGE 7 World War II watchtower. Salice, Sicily, 2005. Numerous watchtowers, bunkers, battlements and fortifications litter the landscape of southern Italy, especially those that had sweeping views of coastlines and valleys. This remnant endures, despite the luxury villas that have sprouted in the vicinity.

PAGE 8 Farm; Ponte Fausto Bisantis. Catanzaro, Calabria, 2001. The Bisantis Bridge, constructed in 1962, is the second largest concrete arch bridge in the world and boasts the second largest arch in Europe.

PAGE 9 Transmission towers. Milazzo, Sicily 2005.

PAGE 11 Gate. Basilicata, 2001.

PAGE 12 Sanctuario. Venetico, Sicily, 2005.

PAGE 13 Botanical gardens. Messina, Sicliy, 2005.

PAGE 15 Olive tree sales lot. Lazio, 2007. As traditional olive plantations are being purchased by developers, the trees—some of which are hundreds of years old—are uprooted and sold as ornamentals.

PAGE 17 Greenhouse. Sicily, 2002.

PAGE 19 Quarried hill. Valdina, Sicily, 2005. For decades this hill was scraped away in order to extract terra cotta clay for local construction projects.

PAGE 21 Unfinished tunnel; Villa S. Giuseppe. Calabria, 2005.

PAGE 22 Roman mausoleum ruins; Mattress. Via Appia, Lazio, 2007. This ancient mausoleum now serves as an informal brothel along one of the few stretches of the Appian Way not designated as an official archeological park.

PAGE 23 Ruins; Pentedattilo. Calabria, 2001. The name, originating with the town's ancient Greek settlers, refers to the rocky, finger-like outcroppings above the town. Abandoned in the 1960s after hundreds of years of earthquake damage (despite an offer of government rebuilding), Pentedattilo is famous for the 1686 Strage of Alberti," the massacre of the Alberti family after a long and dramatic feud with the Abenavoli Family. The only rehabilitated building is the central church, which is often visited by religious pilgrims.

PAGE 25 Road; Trees. Gela, Sicily, 2001.

PAGE 26 Trees; Trapani. Sicily, 2000.

PAGE 27 Melted tower. Palermo, Sicily, 2000. Areas of downtown Palermo still suffer damage from heavy bombing during World War II. Government funding, originally intended for rehabilitation, has been diverted to other projects.

PAGE 29 Santuario Madonna delle Lacrime; Street. Siracusa, Sicily, 2002. The Shrine of Our Lady of the Tears was erected in honor of the miraculous tearing of a plaster effigy of the Immaculate Heart of Mary. This miraculous event was repeated from August 29 to September 1, 1953. The shrine was designed in 1957 by French architects Michel Andrault and Pierre Parat and was constructed over the course of twenty-eight years. It was finally dedicated on November 6, 1994, by Pope John Paul II.

PAGE 31 Le Vele. Naples, Campania, 2003. Le Vele di Scampia (the sails of Scampia) are a large urban housing complex built in Naples between 1962 and 1975. Intended to be a model of urban renewal, the project is infamous as one of the most degraded and problematic neighborhoods in all of Europe. It is marked by poverty, rampant drug abuse and Camorra domination.

PAGE 32 Car park; Trees. Naples, Campania, 2003.

PAGE 33 Piazza; Metro station. Naples, Campania, 2003.

PAGE 35 Football stadium. Messina, Sicily 2005.

PAGE 37 Float pool. Bagnoli, Campania, 2000.

PAGE 39 Unfinished bed and breakfast. Sicily, 2002.

PAGE 41 Ristorante Rose Rosse Zoo. Somma Vesuviana, Campania, 2000.

PAGE 43 Museum interior. Latina, Lazio, 2007. Latina was established in 1932 as Littoria, one of Benito Mussolini's "new cities" constructed atop the swamps natural to the region. This building, a former elementary school now a museum dedicated to a local artist, was designed in common Fascist idiom.

PAGE 45 Rocket monument. Colleferro, Lazio, 2007. Proud of its contributions to the construction of the Ariane 5 rocket, the town placed a section of the rocket in its main traffic circle.

PAGE 47 Finestra sul Mare. S. Stefano, Sicily, 2005. The last sculpture created by artist Tano Festa is this "Window on the Sea." It was created in 1989 as part of a pub-

lic arts project to adorn the northern coast of Sicily. Over the years, the sculpture has been eroded by salt air and general neglect and is now perceived as both a safety hazard and, by many local residents, as a morally indecent eyesore. The government has been indifferent to calls for its restoration and, at the time of this writing, the sculpture is inaccessible to the public and covered by a blue tarp.

PAGE 49 Abandoned World War II military base. Puglia, 2000.

PAGE 51 Overgrown building. Acireale, Sicily, 2002.

PAGE 53 Unfinished church. Gibellina Nuova, Sicily, 2005. In 1968, the ancient town of Gibellina was destroyed by a massive earthquake. A new, "utopian" city, Gibellina Nuova, was built some twenty kilometers from the former town. Many of Italy's most prominent artists and architects had a hand in its design, but it was executed in such piecemeal fashion that parts of the new city bear little relevance to each another or to Sicilian vernacular architecture. Construction of this cathedral was halted in the 1980s due to unforeseen budget shortfalls.

PAGE 55 Quarried hill. Matera, Basilicata, 2000. Ancient tufa quarries surround the historic town of Matera. This is the remnant of a hill, excavated over hundreds of years.

PAGE 57 Abandoned marble display. Calabria, 2001.

PAGE 59 Factory skeleton. Pozzuoli, Campania, 2003. Stripped of its façade, this structure is one of the few reminders of when the area south of Naples was a major manufacturing district infamous as a depository for toxic waste.

PAGE 61 Pylon of Messina; Rainbow. Sorgente, Sicily, 2005. Once carrying the electrical power lines that spanned the Strait of Messina, this tower, built in 1957, is a vestige of that technology now replaced by buried cable.

PAGE 63 Blue pool; Norman castle. Fiume Freddo, Calabria, 2001.

PAGE 64 World War II bunker. Aspromonte, Calabria, 2001.

PAGE 65 Military trench. Sicily, 2005.

PAGE 67 Ristorante. Mt. Etna. Sicily, 2002. Four months after this photograph was made, the village in which this restaurant stands (the highest publically accessible point on Mt. Etna) was buried by a lava flow. Within five years the village had been rebuilt and rededicated.

PAGE 69 Pool; Arabesque; Construction. Messina, Sicily, 2005.

Acknowledgments

The *Architecture of Resignation* is the result of seven years of investigation and several more in writing, design, and production. Colleagues in Italy and in the United States were instrumental in making it possible, and through this project I have made friendships that will endure my entire life.

First, and most importantly, my deepest thanks go to my my wife Avril, my greatest friend, advisor, and soul mate. Throughout this process she has been my support and inspiration—always encouraging, always positive, always sincere. Without her belief in me, none of this would have been possible. My dear friend Martino Marangoni and his wife, Claire, offered assistance and advice for many trips to Italy, supplying technical support, names of assistants, connections of all kinds, and true friendship. My extraordinary friend Alyson Price has given immeasurable perspective on all things Italian and otherwise. Maurizio Berlincioni and his wife, Anna Marie, were sources of friendship and technical help. Many thanks also to my Italian friends Paulo Woods, Alessandra Marchi, Giocomo Tripodi, and Nicola Bellomo.

I could not have made all these photographs without the invaluable help of my expert photo assistants. They provided local knowledge, translation, negotiation skills, technical assistance, keen eyes, and fearless driving. Many times, they insured that I return home to tell my tales. Many thanks to Leandro Di Prinzio, John Koch, Jeff Howington, Cesare Ghedina, Davide Pavone, and Giuseppe Toscano. Here in Chicago, Mary Farmilant has provided incredible production assistance and advice, pushing me to stay on task and complete this project.

Many thanks to writers Roberta Valtorta and Tom Bamberger who gave great thought and many hours to unraveling my photographs. I am very grateful that they were inspired enough to breath extraordinary life and perspective through their insightful essays.

Without the friendship and patronage of Dick Press, Ralph Segall, and Carl Cafaro this book would not have been produced. They believe I am worthy of their support, and I extend my everlasting appreciation to them.

I could not have executed and produced this work without the support of several individuals who not only play key administrative roles at Columbia College Chicago, but whom I count as dear friends. President Warrick Carter, Provost Steve Kapelke, Dean Eliza Nichols, and Vice President Jo Cates have all provided ongoing personal and institutional support.

George Thompson, former Director of the Center for American Places, first approached me about publishing this work. His unwavering commitment and faith kept this project alive. Bob Thall, former Chair of the Columbia College Photography Department, was also a supporter of this work and provided great collaboration. Brandy Savarese, Editorial Director of the Center for American Places at Columbia College Chicago, has shown me what a professional editor should be. Her editorial skills and deep understanding of this work and me, as an artist, are the reason this book has been produced in the way it was always intended. Additionally, I want to thank Jehan Abon, book designer, and Jason Stauter, business manager, for their excellent assistance in the production of this volume.

Dear friends and colleagues have assisted me in countless ways. They include Paul D'Amato, Patty Carroll, Anthony Jones, Jack Jaffe, Naomi Stern, Richard Block, Alan Lerner, Aviva Alter, Wendy and Debi Katz, Olivia Lahs-Gonzales, Ciara Ennis, Martha Schneider, Sallie Gordon, Lara Wolff, Mike Lagen, and David Travis.

Finally, my deepest appreciation goes to all the people in the beautiful and mysterious Mezzogiorno who shared their lives and showed me their generosity, spirit and respect, and provided access to some of the greatest subjects I have ever witnessed. They truly pointed me in countless directions I would have never pursued otherwise.

About the Artist
and Essayists

JAY WOLKE is Chair of the Art and Design Department at Columbia College Chicago where he has been on faculty since 1981. In addition to teaching at Columbia, he has taught photography and art at the School of the Art Institute of Chicago, the Illinois Institute of Technology, and the Studio Art Centers International Florence, Italy. He received a B.F.A. in printmaking and illustration/design from Washington University in St. Louis, Missouri, and an M.S. in photography from the Institute of Design, Illinois Institute of Technology in Chicago, Illinois. Wolke's work has been exhibited widely in the United States and abroad, and is in the permanent collections of the Museum of Modern Art, the Whitney Museum of American Art, the Art Institute of Chicago, and the San Francisco Museum of Modern Art. He is the author of two monographs, *All Around the House: Photographs of American-Jewish Communal Life* (Art Institute of Chicago, 1998) and *Along the Divide: Photographs of the Dan Ryan Expressway* (Center for American Places, 2004).

ROBERTA VALTORTA, critic and historian of photography, is the scientific director of Museo di Fotografia Contemporanea, Cinisello Balsamo-Milan. She has worked in the field of photography since the mid-1970s, particularly on photography as art, languages of contemporary photography, photography and landscape, and public commissions. She she has taught at Centro Bauer, Milan since 1984, and formerly held teaching appointments in the Universities of Milan, Rome, Udine. Valtorta has curated exhibitions and published many books and catalogues on twentieth century photography, including *A vent'anni da Viaggio in Italia* (Lupetti, Milano 2004), *Alterazioni. Le materie della fotografia tra analogico e digitale* (Lupetti, Milano 2006), *Il pensiero dei fotografi. Un percorso nella storia della fotografia dalle origini a oggi* (Bruno Mondadori, Milano 2008), and *Fotografia e committenza pubblica. Esperienze storiche e contemporanee* (Lupetti, Milano 2009).

TOM BAMBERGER has been a working artist, writer, and curator for more than three decades. His photographs have been collected and shown at museums including the Museum of Modern Art, The Art Institute of Chicago, San Francisco Museum of Modern Art, and the Museum of Fine Arts Houston. He has received both the National Endowment for the Arts and Wisconsin Arts Board Fellowships. For more than twenty years he has been a contributing editor for *Milwaukee Magazine* writing hundreds of articles about the visual world, He has been awarded numerous honors for his writing including the Wisconsin Press Club for criticism and the White Award (the national award for city and regional magazines). While working as the curator of photography at the Milwaukee Art Museum Bamberger produced more than thirty exhibitions and publications including the first American showings of work by Andreas Gursky, Anna and Bernhard Blume, and Rodney Graham.